PHOTOGRAPHING NEW YORK

photos by **N.Y.**SEE
text by **William Dello Russo**
Carlo Irek
Giovanni Simeone

AWARD-WINNING
PHOTOGRAPHERS
GUIDE YOU
TO THE BEST SHOTS

SIMEBOOKS

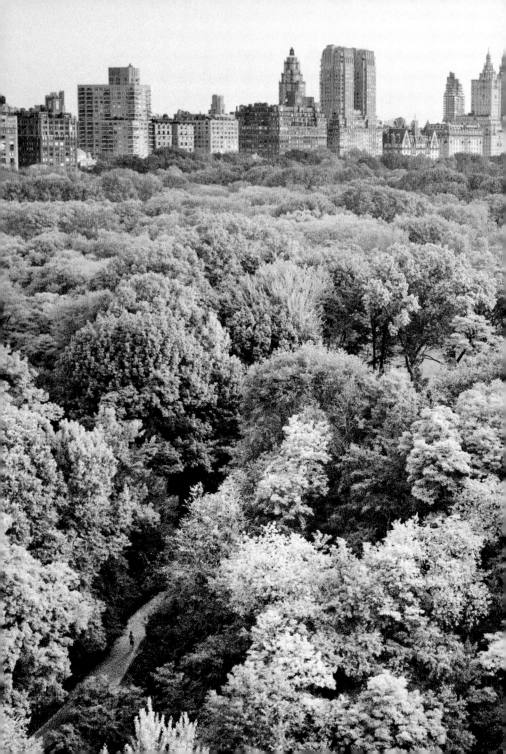

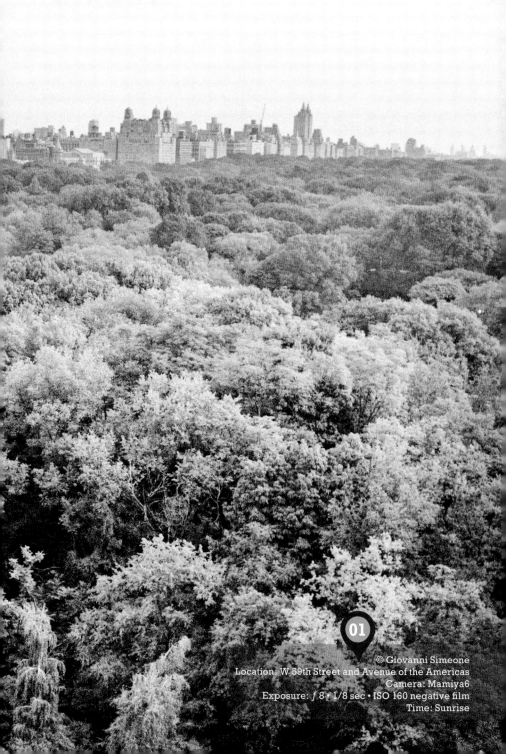

Location: W 59th Street and Avenue of the Americas
Camera: Mamiya6
Exposure: ƒ 8 · 1/8 sec · ISO 160 negative film
Time: Sunrise

Photographing New York is a celebration of one of the world's iconic cities, seen through the lens of an international cooperative of professional photographers and photo agencies at the pinnacle of the city's positive rejuvenation.

"The City" is energized by the people living there, invigorated by a new skyline, the groundbreaking High Line, and many other beautification projects. There's never been a more exciting time to photograph New York City. This book is the culmination of the **NYSEE project**, a **three-year collaboration** between **31 talented professional photographers** and three stock photo agencies: **eStock Photo** (New York, USA), **Simephoto** (Venice, Italy) and **4Corners Images** (London, England). The brainchild of Luz Jimenez of eStock Photo and Giovanni Simeone of Simephoto, the project set out to create **the definitive stock photo collection of New York City**. From the photographers' perspective, it was clear from the start that New York City was no longer the hard-edged concrete and glass proposition so often communicated in earlier image collections. The city was softer, more

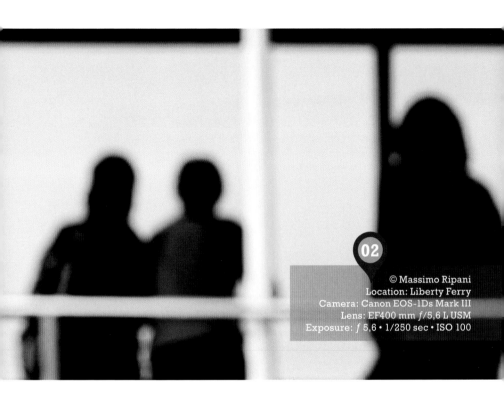

welcoming than any of the NYSEE contributors ever thought possible, and it shows in their work. Certainly, there are architectural icons to capture in a new light, but in the 21st century, it seems important to put buildings into perspective, to make them genuinely relative to the people they're built to serve. Financiers and big businessmen built high to leave a legacy, their personal mark on the city, sparking a megalomaniac frenzy to inspire awe and immortalize themselves. That desire is less pervasive now, and there's an altogether more altruistic and welcoming feel to the city.

Photographing New York is not an instruction manual in the classic sense. It's a study of four cornerstones of photography: **Light**, **Composition**, **Exposure**, and **Seeing** (or Vision) as they've been applied to real-world urban photography by contemporary professional photographers. It's a **visual guide**, an **inspiration for photographers living in or traveling to New York**. From vistas of Central Park to intimate urban details in summer and winter, rain or shine, this glorious photographic exploration of the world's greatest city is a delight for photographers and armchair travelers alike.

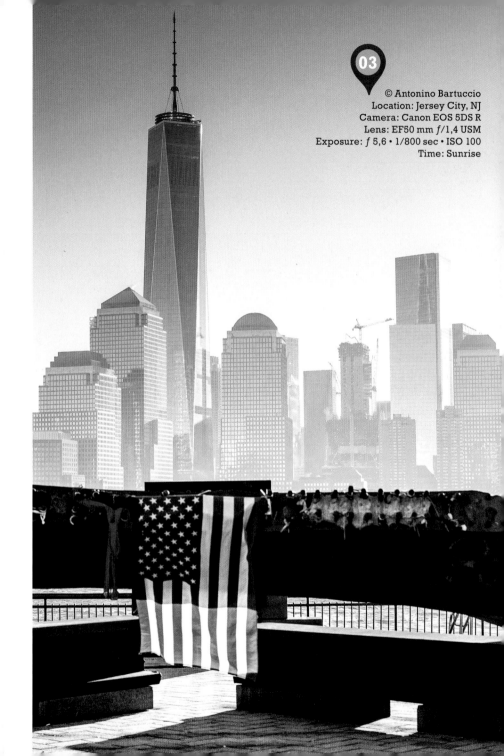

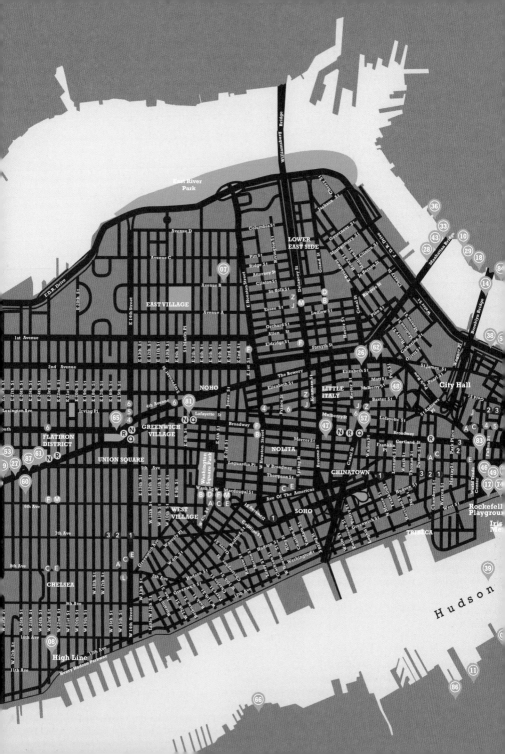

East River

(44)

SOUTH STREET
SEAPORT DISTRICT

FINANCIAL
DISTRICT

Staten Island
Ferry

Whitehall St

3
2
Wall St
2
J
R N
Broad St
1
Pine St / Broadway
5
4
South Ferry Loop
Rector Street
1
Bowling Green
outh End Ave
2nd Pl
1st Pl
BATTERY
PARK

(78) →

(37)

(85)

(75)
(02) (77)
(35)
Statue
of Liberty

(13)

(68)

(30)

(12)

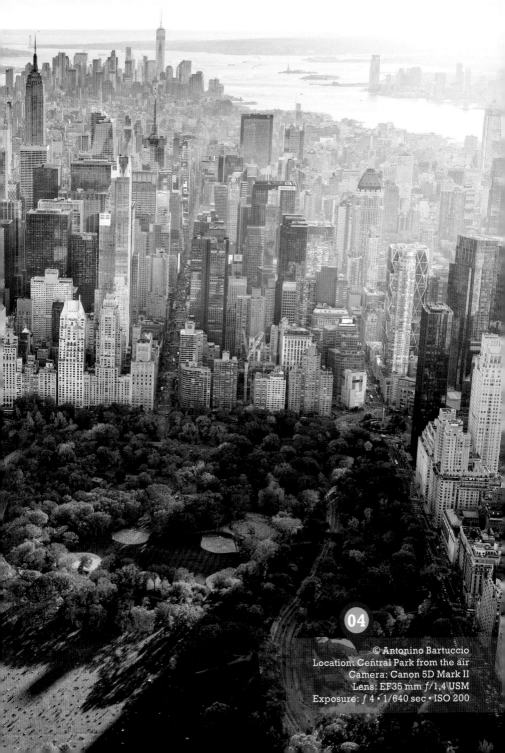

04

© Antonino Bartuccio
Location: Central Park from the air
Camera: Canon 5D Mark II
Lens: EF35 mm ƒ/1,4 USM
Exposure: ƒ 4 • 1/640 sec • ISO 200

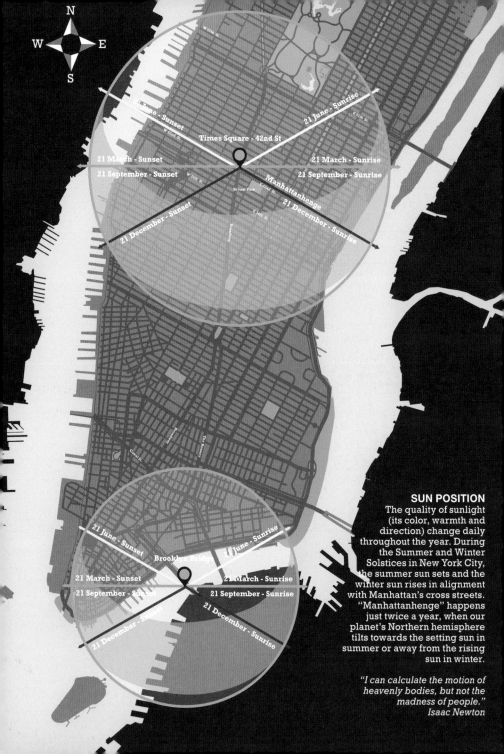

SUN POSITION
The quality of sunlight (its color, warmth and direction) change daily throughout the year. During the Summer and Winter Solstices in New York City, the summer sun sets and the winter sun rises in alignment with Manhattan's cross streets. "Manhattanhenge" happens just twice a year, when our planet's Northern hemisphere tilts towards the setting sun in summer or away from the rising sun in winter.

"I can calculate the motion of heavenly bodies, but not the madness of people."
Isaac Newton

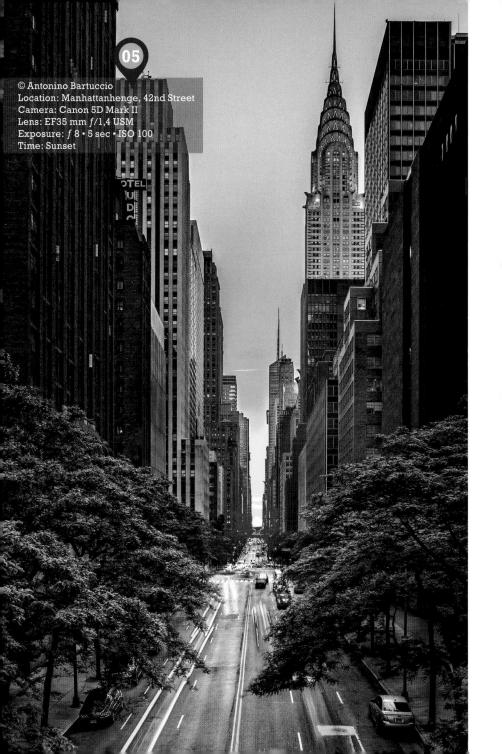

05

06

Location: Times Square
Camera: Canon 5D Mark II
Lens: TS-E45 mm ƒ/2,8
Exposure: ƒ 5,6 • 1/13 sec • ISO 800

Location: Alphabet City, Manhattan
Camera: Nikon D600
Lens: Nikkor AF-S 24-120 ƒ/4 G EDVRII
Exposure: ƒ 7 • 1/50 sec • ISO 200

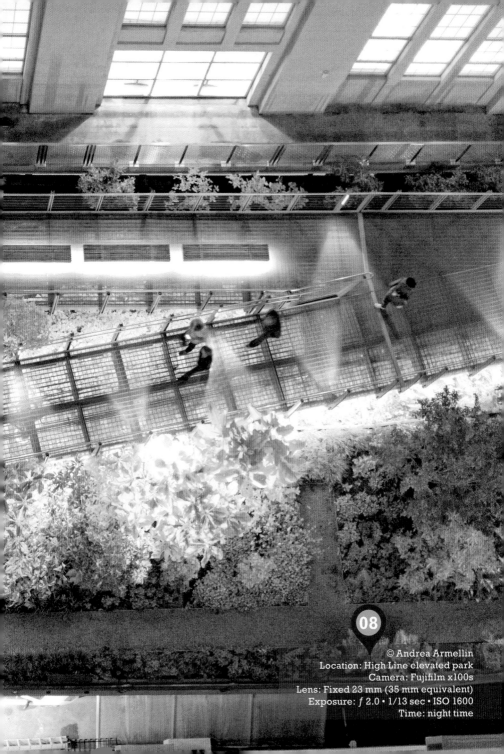

© Andrea Armellin
Location: High Line elevated park
Camera: Fujifilm x100s
Lens: Fixed 23 mm (35 mm equivalent)
Exposure: ƒ 2.0 • 1/13 sec • ISO 1600
Time: night time

LIGHT

light is the single
most important
element in our
work. ...watch it,
study it, follow it. ...

Let there be light. It's ephemeral. You can see what it does, but you can't touch it. It's weightless and invisible, and we only see its effect on our scene or subject. It gives shape and form, colour and texture, scale and distance to our three dimensions, but for all its paramount importance in image-making it's often overshadowed by other distractions.

As photographers, light is the single most important element in our work. We should watch it, study it, and follow it with passion; because without it, in all its characters, our work simply doesn't exist.

When shooting with available light (most often sunshine), photographers should be aware of the color of light, its direction, and quality; whether it's softened by cloud cover or if it's hard and bright as on a sunny day. When considering the properties of the

light in their scene, professional travel photographers often decide not to shoot almost as often as they decide when they should squeeze the shutter release, making a conscious decision to come back at another time of day to find a different quality or direction of light that suits their images better. Light dictates mood through shadows, highlights, and contrast; its direction reveals textures in our subject. The difference between a good shot and a great shot can be that lick of light that draws the eye to our subject or point of focus. Its ever-changing character is the very reason we set out to make pictures, and when the summer sun takes just ten minutes to traverse Fifth Avenue, switching the light and shadow from one side of the street to the other, New York City makes a fantastic place to study the mood swings of light.

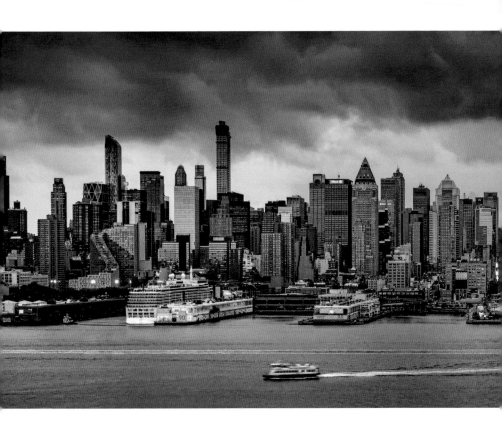

SKYLINE
FROM HOBOKEN

Few images sum up a city–any city–like a shot of its skyline.
To the natives, it says "home," a place where they belong, and to visitors
a new horizon. For instantaneous recognition, few skylines of any city come
close to New York. But there is a unique quality to this photo, taken from
Hoboken, on the west side of the East River. The sky is heavy, burdened with
black, menacing clouds. The river reflects the leaden sky: two dark stripes
frame the world's most beautiful skyline, and at the same time the piers on
the river open out symmetrically, radially. Only a band of light still staves off
the brewing storm and glitters from the windows at sunset.

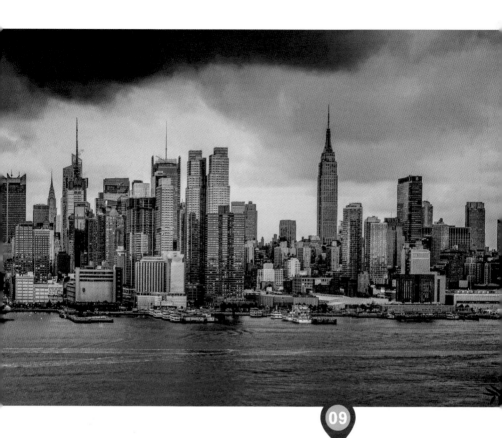

09

© Antonino Bartuccio
Location: **Hoboken, NJ**
Camera: **Canon 5D Mark II**
Lens: **24-105 mm @ 80 mm**
Exposure: *ƒ* 8 • 0,3 sec • ISO 320

This is the right moment to shoot,
capturing the contrast between the
splendid architecture and the dark
mystery of nature.

BROOKLYN BRIDGE AT NIGHT

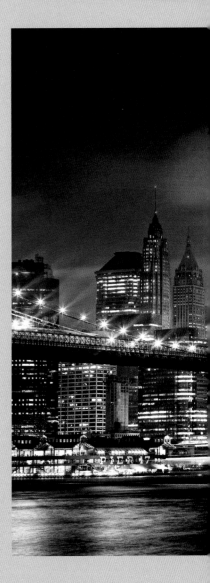

From Main Street Park in Brooklyn looking towards the bridge and Wall Street skyline: it doesn't get more classic than this. The picture could appear almost banal: it is probably the world's most often seen and best known image, here given an antique flavor in black and white. A photo taken at around 8.30 in the evening under a sky foreboding nothing good, with clouds building up darkly. The lights have gone on, the city is reflected in the clouds, while the skyscrapers are still bustling with the rhythm of life that never slackens its hectic pace. Using a tripod, so as to get a slower shutter speed, adds a dreamy touch to the gently moving clouds and water, and makes Wall Street stand out even more strikingly than usual.

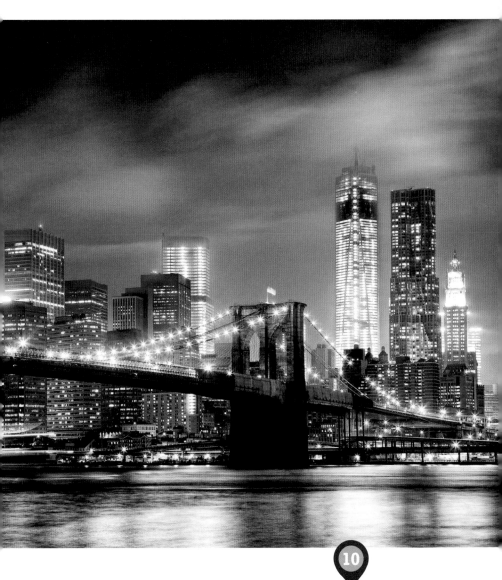

© Luigi Vaccarella
Location: Main Street Park, Brooklyn
Camera: Canon 5D Mark II
Lens: 24-70 ƒ/2,8 L USM @ 65 mm
Exposure: ƒ 8 • 15 sec • ISO 200

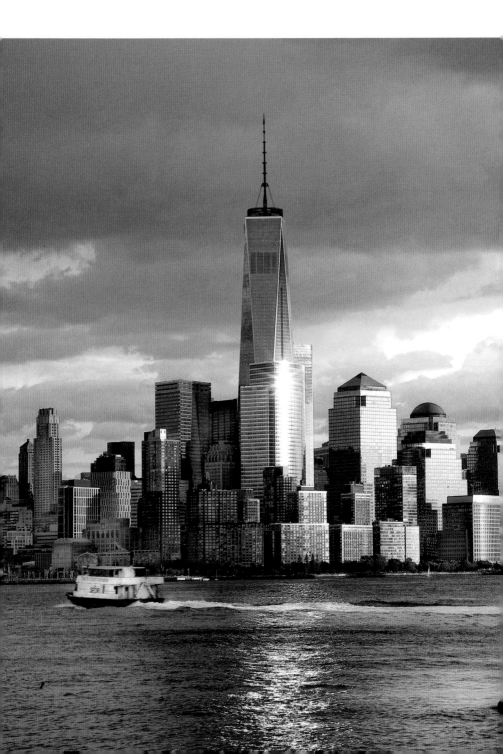

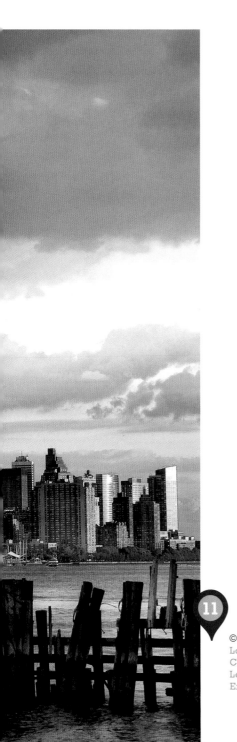

SKYLINE FROM HOBOKEN

Not many visitors, even among photography buffs, cross the Hudson to get to New Jersey, and it's a shame, because a 10-minute ferry ride makes it easy to access kilometers of riverfront promenade with spectacular views like this. New York rises majestically from the sea straight into the sky. With no hills, mountains or high ground to command, the entrepreneurs, financiers, and industrialists built tall, and taller still. This photo was taken from Hoboken, New Jersey. Many would argue that the most important thing for a photographer is to have a good eye, but if you're a landscape photographer, feet are also important! You always have to walk up and down for hours and hours along the riverside. The light was exceptional that day, but good luck will only find you if you're at work.

11

© Anna Serrano
Location: **Hoboken, NJ**
Camera: **Canon EOS 5D Mark II**
Lens: **EF24-105 mm ƒ/4 LIS USM @ 75 mm**
Exposure: **ƒ 22 • 1/10 sec • ISO 100**

LIGHT SKYLINE

FREEDOM TOWER & STATUE OF LIBERTY

Evening is a magical time, when the bright lights of Manhattan's skyscrapers and the floodlit Statue of Liberty stand out against the inky sky. Then the photograph brings out the founding value of the US in the two principal landmarks seen against the gloom: the gilded torch of Lady Liberty and the antenna of the One World Trade Center, better known as the Freedom Tower. This was a difficult shot to take because viewpoint is a pier in New Jersey that can only be reached on foot, some distance from any subway station, while taxis shy away from it. Only container trucks pull over here. Technically the shot was taken with a long telephoto lens and a very solid tripod. On the sea you always have to reckon with a slight breeze.

12

© Antonino Bartuccio
Location: **New Jersey, NJ**
Camera: **Canon 5D SR**
Lens: **EF100-400 mm** f/4.5-5.6L IS II
USM @ 400 mm
Exposure: f 8 • 20 sec • ISO 50

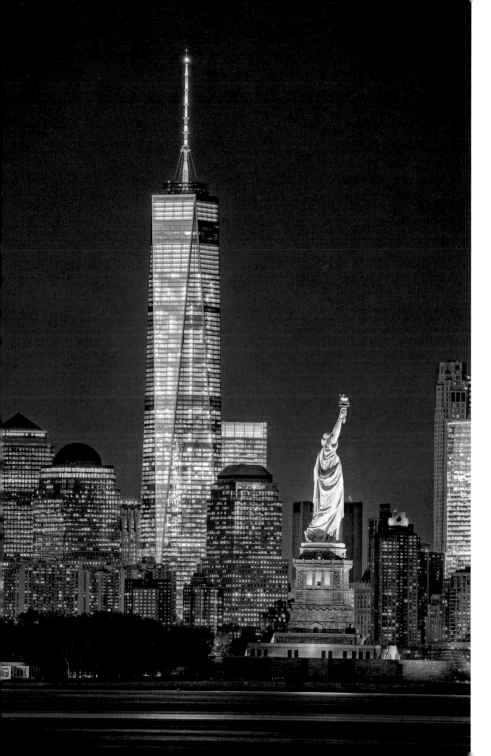

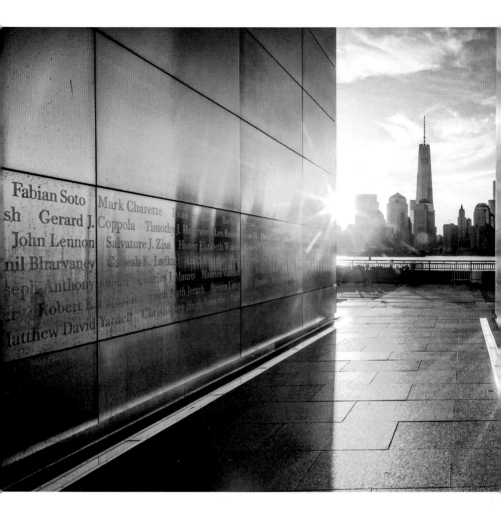

EMPTY SKY
9/11 MEMORIAL

A new view of New York and the Freedom Tower on a clear spring dawn.
With this wide angle backlit view through the memorial, the names of the
commemorated victims of September 11 are kindled by the golden sunrise,
but the eye doesn't dwell on them. The view is always forward into the
new day's dawn, to the new skyline and the Freedom Tower, taller than the
iconic towers that stood there before. Technically a 3 stop neutral density

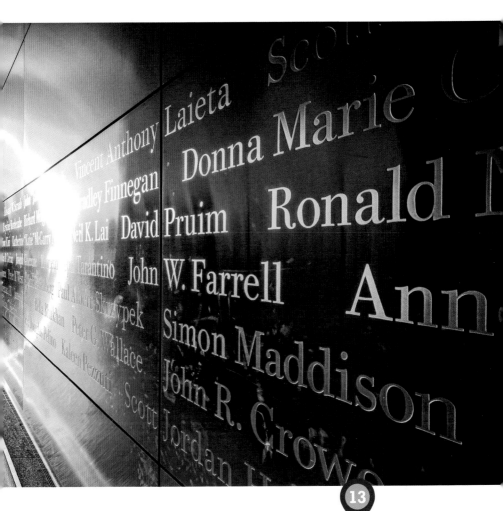

© Maurizio Rellini
Location: **Liberty State Park,
Jersey City, NJ**
Camera: **Canon 5d mk III**
Lens: **TS-E24mm ƒ/3,5L II**
Exposure: **ƒ 18 • 1/30 sec • ISO 250**

filter helps control the brightness of the backlit sky. The new-generation sensor allows for contrast control that would have been unimaginable only a few years ago. A small aperture and the use of a fisheye lens create strong vanishing lines leading from the first letter into the distance all the way to Manhattan's skyscrapers.

LIGHT SKYLINE

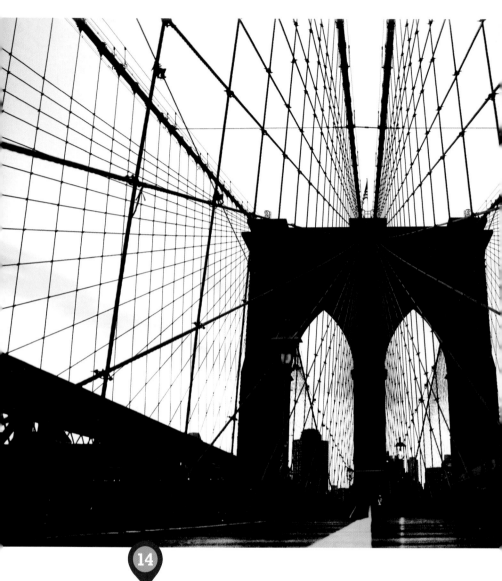

14

© Massimo Ripani
Location: **Brooklyn Bridge**
Camera: **Canon EOS-1Ds Mark III**
Lens: **EF24-70 mm** f**/2,8 L II USM @ 24 mm**
Exposure: f **2,8** • 1/100 sec • ISO 400

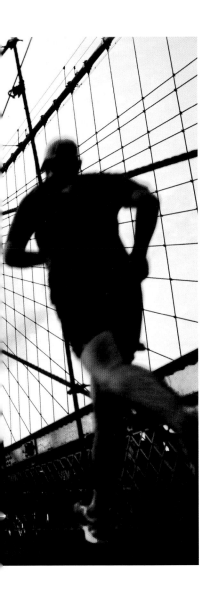

RUNNING ON BROOKLYN BRIDGE

The runner's silhouette, caged between the steel stays of Brooklyn Bridge, is accentuated by marked overexposure to dramatize the composition. The black lines of the cable stays stand out against an overexposed, almost burned-out sky. The image immediately becomes iconic. This intense chiaroscuro effect was obtained with a mid-morning shot. The camera was positioned on the deck, the catwalk trodden daily by thousands of people (an issue to bear in mind is the strong vibrations caused by the continuous pounding of the runners).

LIGHT CONTRAST

CHRYSLER BUILDING AT SUNRISE

The canyons of Manhattan and Brooklyn naturally offer excellent contrasts of light and shadow. In this photo, a limpid dawn kisses the city. Apart from the photographer, the man in the street seems to be the only one there to enjoy it. The sun peeps between the skyscrapers and illuminates the three vertical elements that mark this spectacular shot in totally different ways: pitch black at the left, the brick building on the light, barely awakening from the darkness, and the shimmering Chrysler Building.

The strong contrasts and deep black shadows bring out the highlights picked out by the sun, creating a dramatic depth, a three-dimensional perspective unknown to most photographs, which are born two-dimensional. The spectacular sensor mounted on this camera then allows for total control during the image processing. We're in a new age of photography.

15

© Massimo Ripani
Location: **Chrysler Building**
Camera: **Canon EOS-1Ds Mark III**
Lens: **TS-E17 mm ƒ/4L @ 17,00 mm**
Exposure: **ƒ 16 • 1/40 sec • ISO 100**

LIGHT CONTRAST

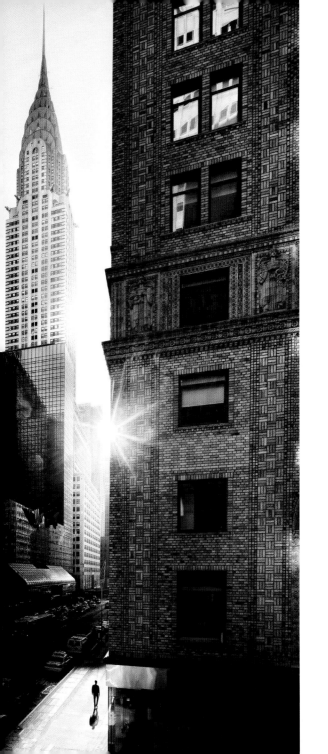

MANHOLE STEAM

The steam rising out of manhole covers remains one of New York's great mysteries. This is well known to photographers, who exploit it to create spectacular contrasts. Black and white naturally brings out the best effects. The contrasts can be harsh, and careful compensation is essential to prevent the loss of important detail in the shadows, the most delicate part of the picture. A meter reading taken only in the central area would be misleading, and since we often forget to change the type of exposure reading, it is best to compensate directly during shooting. The slightly oblique angle of the shot, the two skyscrapers chopped in half, the big pool of darkness in the right-hand corner, and the wonderful silhouette of the man and dog caught perfectly against the misty cloud heighten the slightly surreal and estranging effect of the composition.

16

© Antonino Bartuccio
Location: **Long Island City, Queens**
Camera: **Canon 5D Mark II**
Lens: **24-105 mm @ 24 mm**
Exposure: *f* **8 • 1/1000 sec • ISO 100**

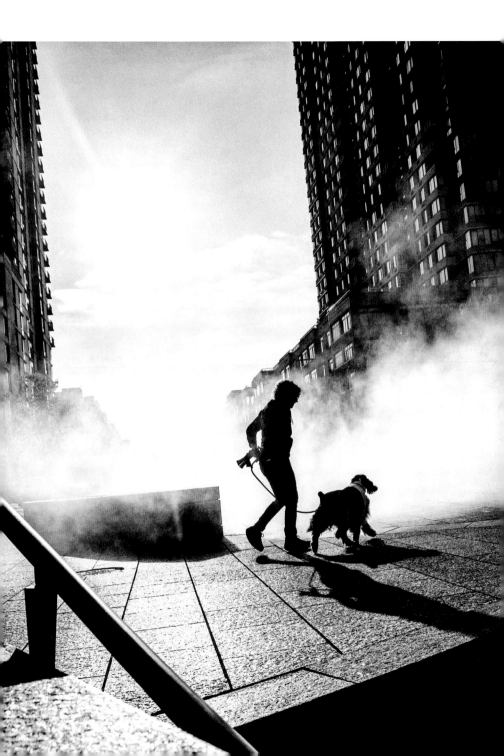

FREEDOM TOWER (YANKEES)

This shot of the Freedom Tower from Ground Zero captures the sharp contrast between the adamantine glitter of the skyscraper and the silhouettes of the two figures.
A wide-angle lens makes it possible to capture widely separated features, like the skyscraper and the back view of the man, in the rectangle between them, making them peripheral details, particular and general, within a single shot. And black and white, masked as in a darkroom (you can almost see the hands between the lens and the photographic paper), with its magic escapes from the tourist banality of color. Finally the word "Yankees" picked out on the man's sweatshirt is a stroke of genius because it evokes just where we are, while mirroring the glow of the glass skyscrapers, gradually fading at the sides.

17

© Massimo Ripani
Location: One World Trade
Center, Manhattan
Camera: Canon EOS-1Ds Mark III
Lens: TS-E17 mm f/4L @ 17 mm
Exposure: f 7,1 • 1/320 sec • ISO 100

LIGHT CONTRAST

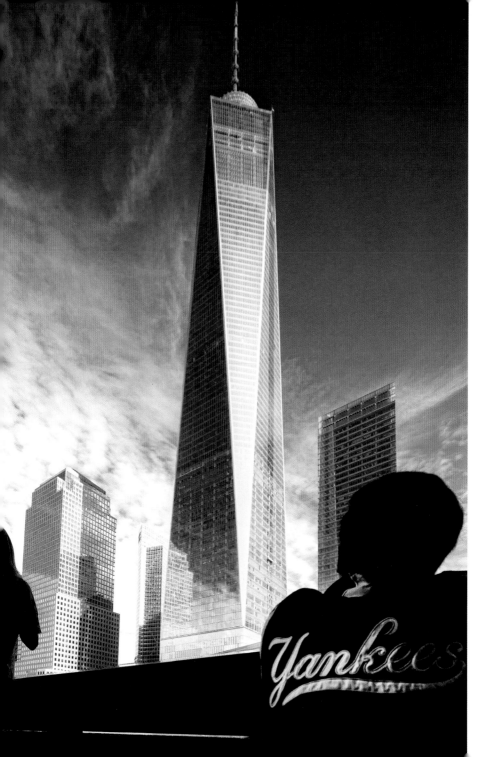

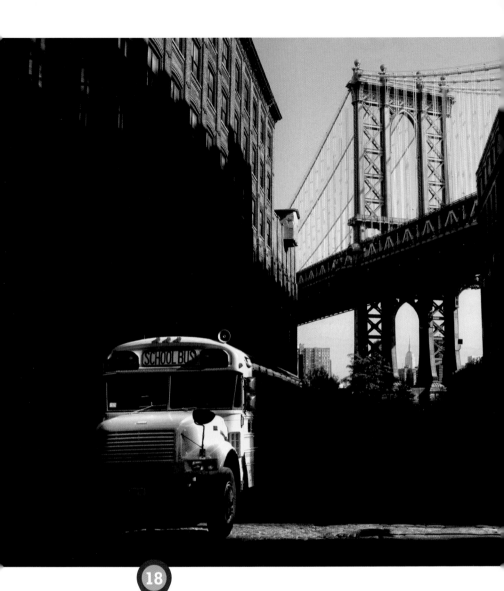

© Gabriele Croppi
Location: **Dumbo, Brooklyn**
Camera: **Canon EOS 5D Mark II**
Lens: **Zeiss Vario Sonnar 20-85 mm**
Exposure: f 11 • 1/320 sec • ISO 100

SCHOOL BUS IN DUMBO DISTRICT

How to get an original shot of one of the most photographed places in New York, inexorably fixed in the collective memory by the movie *Once Upon a Time in America*? The most important thing is to shoot it in different conditions of light, returning several times to the same spot, until you find just the right angle of light, the special situation when the sunlight casts a graphic image. The effect is accentuated by the deliberate decision to underexpose, so that the shadows lose all detail, being completely blocked out. Another point that is often overlooked, but extremely important, is the quality of the light: the day has to be perfect and the atmosphere very clear (common enough in New York), without mist or clouds shading the sunlight. These conditions make it possible to get very sharp images with marked contrasts.

CLIMBING A ROCK IN CENTRAL PARK

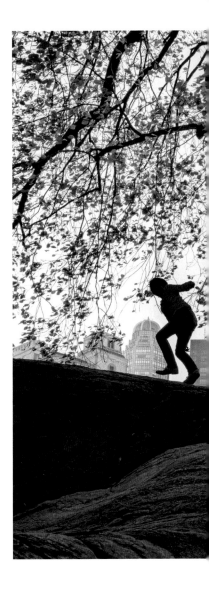

While walking in Central Park, the photographer noticed the juxtaposition of the man-made concrete jungle rising above the all-natural shapes to be seen and enjoyed in the city's favorite park. The city is backlit, the light on the buildings shadow-free, the tree, and rock almost silhouettes. As so often happens when working in a busy city, someone broke into the shot as the photographer was framing the boulder, the tree and the West 59th Street skyline in the viewfinder; but this time, the intruder brought the picture's contrasting elements together: the wildly simian silhouette makes one wonder whether this creature came from the city, or fell from the tree? The expedient of keeping the buildings and the tree in the shadow secures better control over contrast–strongly marked, given the nature of the photo–and makes the whole shot more clearly legible.

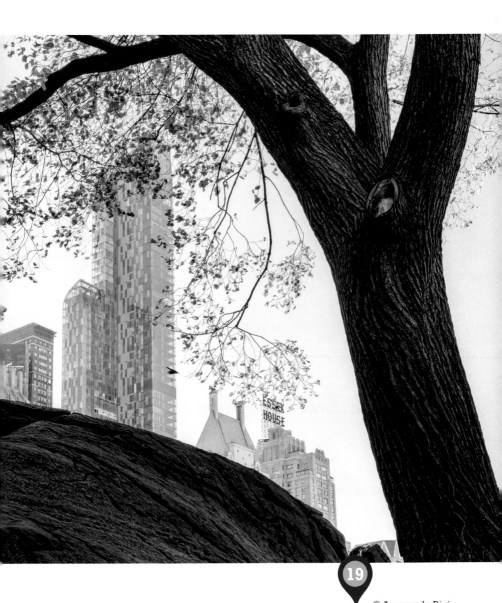

© Arcangelo Piai
Location: **Central Park**
Camera: **Nikon D800E**
Lens: **Nikkor 50 mm ƒ 1,4**
Exposure: **ƒ 8 • 1/250 sec • ISO 200**

THE BOW BRIDGE AND THE LAKE

Central Park is a real joy for photographers. In spring the trees are covered with green leaves and flowers; in autumn everything is transformed within a few days into a symphony of yellows and reds. In this photo, the light of early morning perfectly sculpts the decorations on Bow Bridge, the square volumes of the San Remo Apartment Building, and the splendid scarlet foliage. In the waters of the lake, the light picks out the belly of the bridge and a part of the park that would otherwise remain unseen.

With reflections in water, the difference in brightness between reality and the reflection is about 2 to 3 stops, so a graduated neutral density filter (best hard in this case) helps control the image and can be further adjusted at home with greater precision.

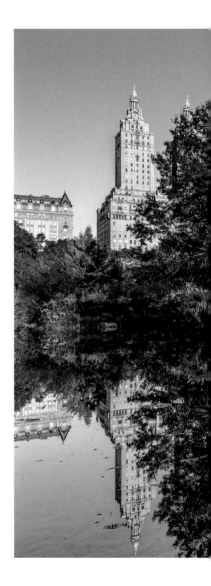

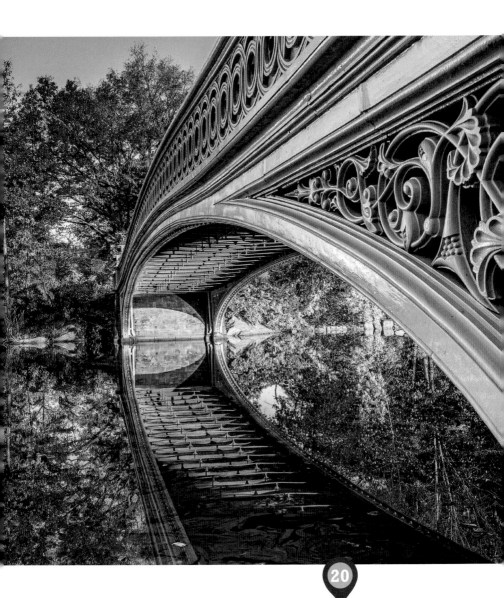

20

© Antonino Bartuccio
Location: **Central Park**
Camera: **Canon 5D SR**
Lens: **TS-E24 mm** f/3,5 L II
Exposure: f 8 • 1/125 sec • ISO 100

CENTRAL PARK FROM THE TOP OF THE ROCK

The Top of the Rock is both a place to arrive at and a departure point. A photographer just has to climb it, to get some of the most iconic photos of New York. And only after wearing out your sensor from the city's most beautiful terrace will you be ready to look for something new, more intriguing, and unseen– or little seen, given that it's in one of the world's most photographed places. This is one of the images that gives the best idea of Central Park: a green lake completely surrounded by tall buildings.

The photo has a delicate contrast. The side light illuminates the green in the distance. The sky is controlled with a graduated grey filter or double exposure, and darkened to balance the part of the park in shadow.

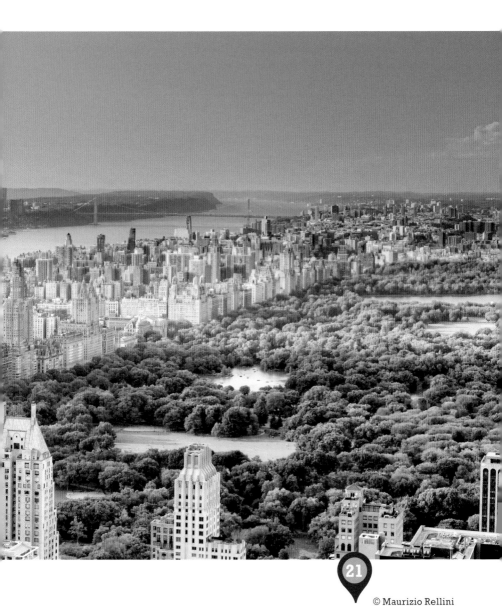

21

© Maurizio Rellini
Location: **Top of the Rock,
Rockefeller Center**
Camera: **Canon 5D Mark III**
Lens: **Canon 70-200 ƒ 2,8**
Exposure: **ƒ 8 • 1/100 sec • ISO 800**

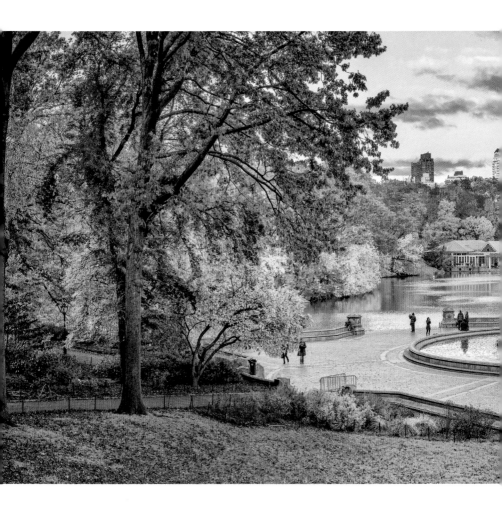

BETHESDA FOUNTAIN

Here we have a glowing painterly image, imbued with a great sense of calm, a picture-perfect postcard of Central Park. Nothing reminds us we are in the midst of one of the world's greatest cities. Instead of looking for contrasts between light and shade, here the photographer opted for a soft light that gently caresses the natural setting and the fountain, creating a meditative fable. The result is a balanced composition, devoid of depth and drama, one which represents an almost ideal place where

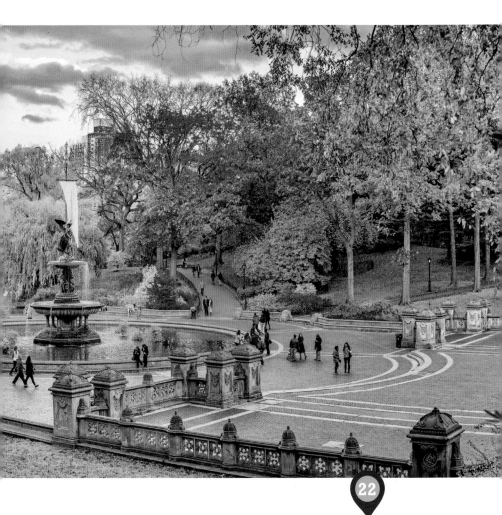

© Pietro Canali

nature triumphs.

Technically, the most significant aspect is the color balance, skillfully handled by a graduated light grey filter placed in the sky area. But the dominant quality here is not technical mastery so much as idyllic interpretation: in the end it is the photographer's eye that creates the image, not the camera.

© Pietro Canali
Location: **Central Park**
Camera: **Canon EOS 5D Mark III**
Lens: **EF70-200 mm _f_/4L IS USM @ 70 mm**
Exposure: **_f_ 8 • 1/125 sec • ISO 800**
Other Equipment: **ND Grad filters Panoramic of 11 vertical photos**

LIGHT CENTRAL PARK

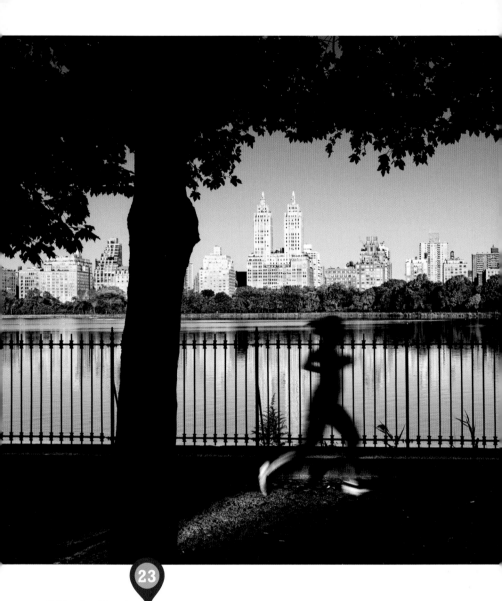

© Massimo Ripani
Location: Jacqueline Kennedy Onassis Reservoir, Central Park
Camera: Canon EOS-1Ds Mark III
Lens: EF24-70 mm $f/2,8$ L II USM
Exposure: f 13 • 1/40 sec • ISO 50

JOGGING IN CENTRAL PARK

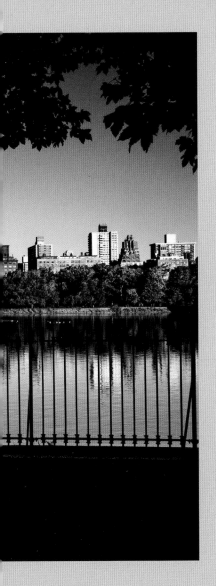

Nothing is left to chance in this photo. These are the points that make it so iconic: the classical composition of the shot with the big tree and the ground framing the subject, and the strong contrasts separating the planes of action; the landscape forming the backdrop, with the Upper West Side dominated by the Eldorado Building; and the silhouette of the girl lit up only where a spot of light unexpectedly falls on her running shoes. It's not always possible to seize the moment for the perfect shot so, especially in crowded situations like Central Park, you can resort to a collage of multiple shots, as in this composition.

LIGHT CENTRAL PARK

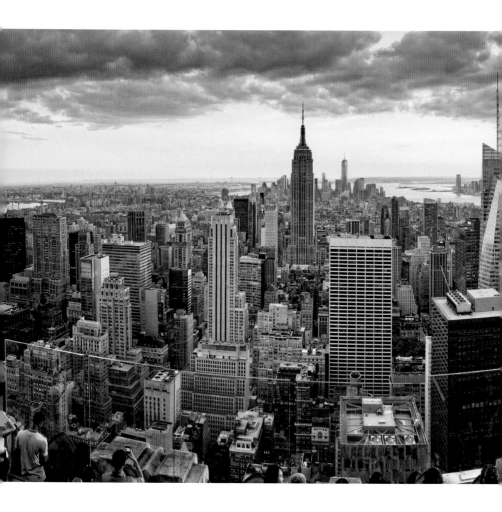

TOP OF THE ROCK

Rooftops bring striking views of the world, but then they have the
disadvantage of invariably being crowded. If you want to capture
a breathtaking sunset like this, make sure you get to the top of the
Rockefeller Center well before the sun goes down. Occupy your space
and defend it in the crush! This view is a must in New York; there's no
avoiding it. But remember competition for this photo is tight.
Here you will measure your skill and know your worth once and for

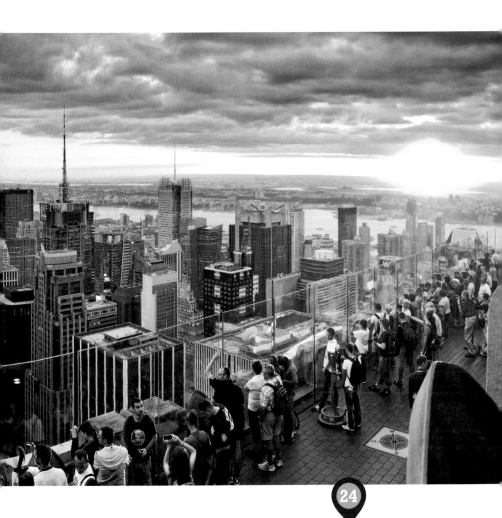

24

© Luigi Vaccarella
Location: **Rockefeller Center**
Camera: **Canon EOS 5D Mark II**
Lens: **TS-E 24 mm ƒ/3,5 L II @ 24 mm**
Filter: **Lee Neutral Density 0.6 Soft Gradient 0,6 Hard Gradient**
Exposure: **ƒ 8 • 1/50 sec • ISO 640**

all, as you gaze at your creation in Lightroom. You're not allowed to use a stand on Top of the Rock: so aim it like a monopod, rotating the head to get this spectacular cylindrical effect.

LIGHT ELEVATED VIEW

UMPIRE ROCK

There's something a little surreal about the transition from the tranquility of Central Park to the noise and bustle of the city, and Umpire Rock is the perfect spot for New Yorkers and tourists alike to sit and watch the lights of Manhattan come on at night. It's a favorite spot for couples, and the photographer came across this romantic scene just before dusk on a cool summer evening in late June. He waited for the natural light at the end of the day to give way to night, when the neon and sodium light sources of the city become prominent. But photographers should be aware that finding an acceptable white balance setting can be tricky when natural light is mixed with artificial light. In this case, the white balance was set to daylight and the artificial lighting tweaked in post production. Having found a pleasing composition he was lucky that the couples stayed in position during an 8 second exposure.

25

© Richard Taylor
Location: **Central Park**
Camera: **Canon 5D mark II**
Lens: **17 - 40 f4 lens @ 17 mm, polarizing filter**
Exposure: ƒ 11 • 8 sec • ISO 200

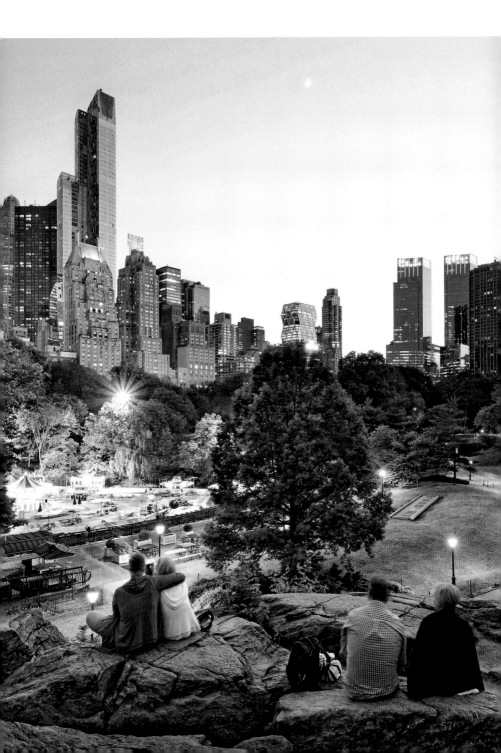

CHINATOWN IN A FOGGY MORNING

For a photographer, a white or grey sky is often a drama: flat light, low contrast, a featureless and suspended situation. Countermeasures are urgently required. The best way to exclude the sky as far as possible, is to climb as high as you can get (to the top of a skyscraper, a platform, or whatever else is available) and snap your shot from above.

The absence of contrast flattens colors and makes everything monotonous, so the idea of shooting the colorful graffiti is precisely to create a break, a contrast with the dominant grey. In this photo there are no special technical devices, only the clever idea of choosing the right subject on a difficult day.

* By their nature, urban murals and graffiti are impermanent. The publisher apologises if the City of New York painted this wall.

26

© Paolo Giocoso
Location: Chinatown, Manhattan
Camera: Canon Eos 5D Mark III
Lens: 35/2
Exposure: ƒ 9 • 1/320 sec • ISO 400

LIGHT ELEVATED VIEW

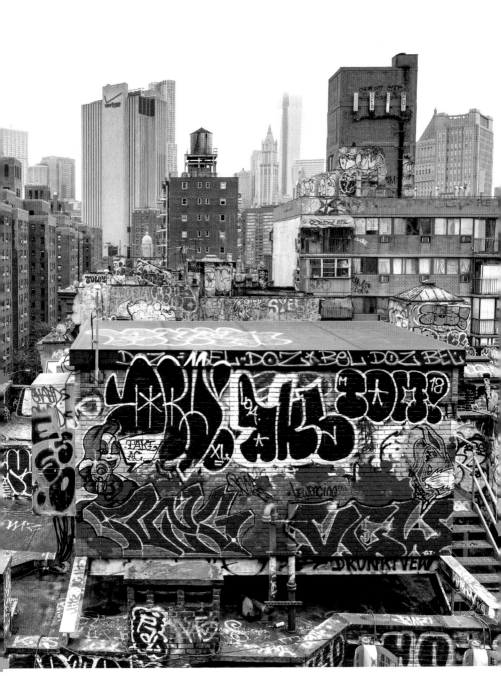

EMPIRE STATE BUILDING

The Empire State Building taken
from a bar terrace–nothing could be
more obvious or commercial.
You go in, order a beer, choose the
best table for the shot, and as soon
as the waiter turns his back, you
take your picture and leave.
Then it turns out it's raining, there's
no happy hour, the chairs are
wet, and the waiters are unhappy.
Usually the wily photographer goes
home to rest up, while the reporter
refocuses and looks for something
else. It turned out to be not the
perfect, soft, sparkling, happy-life
image everyone has in mind, but
a rather intimate, silent New York,
in a misty and melancholic shot.
Undoubtedly unique and original.

27

© Anna Serrano
Location: **230 Fifth Rooftop Bar, Manhattan**
Camera: **Canon Eos 5D Mark II**
Lens: **EF24-105 mm f/4L IS USM @ 24 mm**
Exposure: **f 5,6 • 1/100 sec • ISO 2000**
Other Equipment: **Tripod**

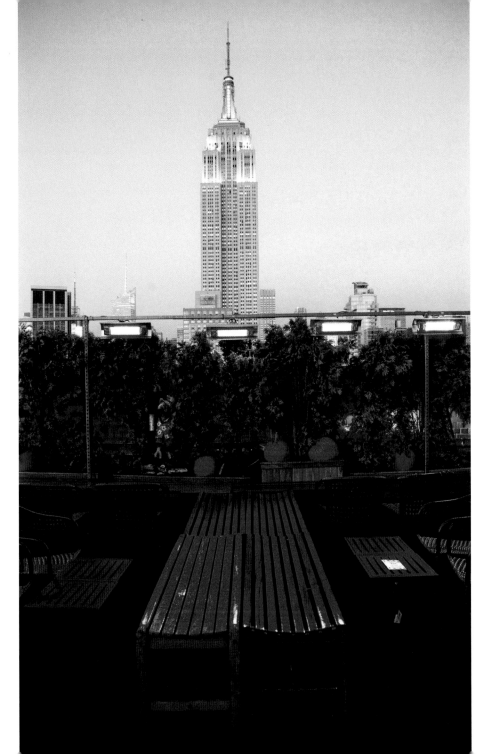

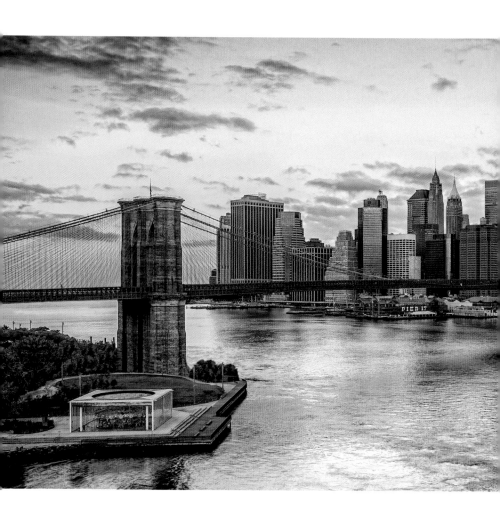

LOWER MANHATTAN AT DAWN

Another absolute must to add to your New York photo collection.
Each dawn has a different flavor, and you always return home proud to have
seen yet another one, feeling superior to all the other sleepy people who can
only say "I wish I had" instead of "I did"! At dawn Manhattan emerges from
the water in all its still unripe glory, ready to mellow with the advancing light.

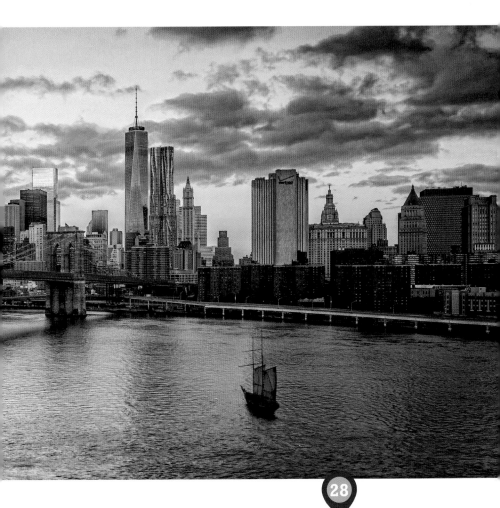

28

© Antonino Bartuccio
Location: **Manhattan Bridge**
Camera: **Canon 5D Mark II**
Lens: **TS-E24 mm ƒ/3,5 L II**
Exposure: *ƒ* 11 • 0,6 sec • ISO 100

The fairly high standpoint was on the Manhattan Bridge. Just find a hole in the fence left by some photographer and place yourself level with the Brooklyn Bridge to get a view of the skyline of Lower Manhattan. A graduated grey filter will help control the highlights in the sky, and you can bring out all the watery tones once you're back home.

LIGHT ELEVATED VIEW

COM POSI TION

COMPOSITION

creative
composition
can make the
everyday exciting,
the mundane
fascinating

If light is essential to our image, then composition is the frame on which we drape light's soft caress or hard, sharp shadow.

If light envelops or spotlights our subject, then composition is the interplay of light and subject that captivates your audience, brings your images to life, and makes them memorable.

Composition influences the way your audience sees your work, and determines whether they will see and feel what you did when you captured the shot.

Composition sets the mood for the communication between photographer and audience: it can be peaceful and contemplative or restless, anxious, inquiring, or disturbing.

Our audience examines our work for significance or to learn something about us as photographers. If you pay attention

to the key elements or qualities
that make your scene or subject,
if you focus on them, you can often
enhance them by simplifying the
scene. Blurring the background
with a wide lens aperture or
choosing a different viewpoint can
remove or minimize distracting
elements from the frame and focus
your audience's attention.
Your choice of lens or focal length
will be crucial to composition,
so too will the position of the key
elements that make your image.
In the cityscape, leading lines and
diagonals are everywhere, but
focusing the viewer's attention in
one of the world's busiest cities
is a challenge, and creative
composition can make the
everyday exciting, the mundane
fascinating.

MANHATTAN BRIDGE REFLECTED

Always a magnet for photographers, Brooklyn Bridge Park offers spectacular views of the Manhattan skyline and the East River bridges. It's also the home of Jane's Carousel, a lovingly restored antique fairground ride, which is protected from the extremes of New York's weather in a sparkling modern glass pavilion. Here, the glass wall of the pavilion creates a virtual mirror image of one of New York's beautiful suspension bridges.

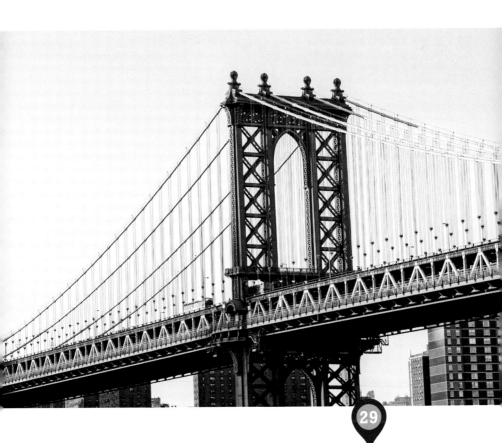

29

© Jordan Banks
Location: **Brooklyn Bridge Park**
Camera: **Nikon D800**
Lens: **24-70 mm** f **2,8 @ 35 mm**
Exposure: f **8** • **1/160 sec** • **ISO 200**

BASKETBALL HOOPS

It would be difficult to apply symmetry more rigorously than in this photo. The lines of the backboards and hoops seem drawn specifically to express the serenity of the vision. There's something reassuring in a symmetrical composition, a kind of magic that excludes chaos.

A simple image and, as with all simple but beautiful things, it's riveting. We wonder why we don't see reality like this, because we always feel compelled to cram more into the frame. But here the effort is the opposite: the photographer sees absence and wants to give it a form. Inspirational.

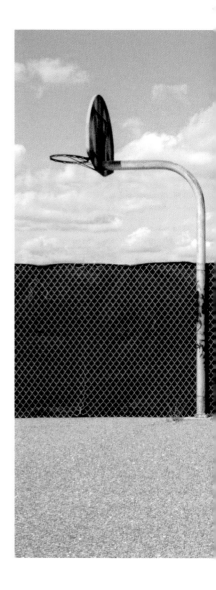

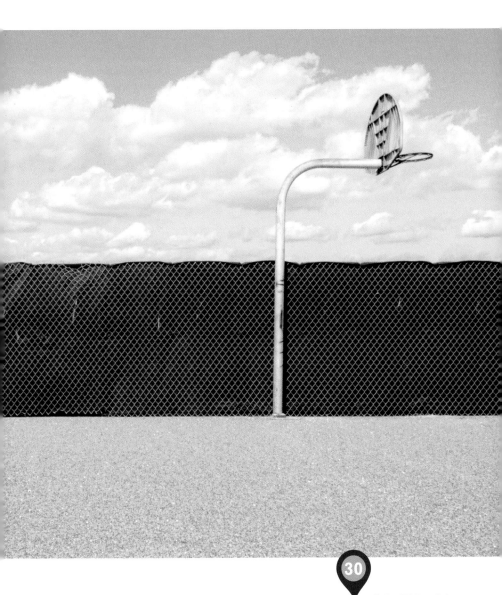

30

© Tim Wainwright
Location: **Rockaway, Queens**
Camera: **Canon EOS 400D Digital**
Lens: **EF-S18-55 mm** f**/3,5-5,6**
Exposure: f **20 • 1/500 sec • ISO 1600**

INTREPID

The aircraft carrier *Intrepid* is a truly amazing subject. As in a movie, young sailors have themselves snapped with their elegant girlfriends in front of it, while tourists flock from every corner of the United States, attracted to its legend as well as its outsize scale. The ship's name itself is a formidable challenge to the photographer, and the picture has to measure up. The choice of black and white could be a good starting point. Technically, a tripod enables you to create a perfect symmetry. A bubble level will ensure the camera is perfectly straight, and a good wide-angle lens will avoid distorting the image. These little details separate a photo taken with care from a merely humdrum shot.

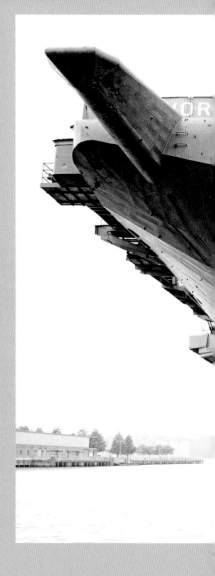

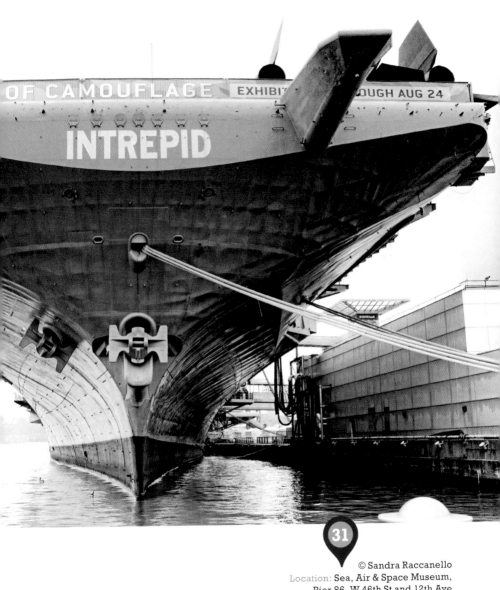

© Sandra Raccanello
Location: Sea, Air & Space Museum,
Pier 86, W 46th St and 12th Ave
Camera: Canon 5D
Lens: EF28-135 mm ƒ/3,5-5,6 IS USM
Exposure: ƒ 11 • 1/125 sec • ISO 400

QUEENSBORO BRIDGE

A lot of you will naturally try to reproduce the classic shot from Woody Allen's movie *Manhattan*. So it's too bad that the construction of the aerial tramway to Roosevelt Island has totally changed that image, sending it straight to history. In any case, the cinematographer was not interested in that subject, because his inspiration was seized by the bridge's massive metal structure. Extract the subject, strip it of all recognizable parts, frame it in a perfect symmetry, and spot meter exclusively for the metalwork, while ignoring everything else. This is the way to take a powerful and unique minimalist photo.

32

© Olimpio Fantuz
Location: **Queensboro Bridge**
Camera: **Canon 5D Mark II**
Lens: **24-70 2,8 LII 44 mm**
Exposure: *f* **11 • 30 sec • ISO 400**
Other Equipment: **Neutral Density Filter, tripod Gitzo Mountaineer**

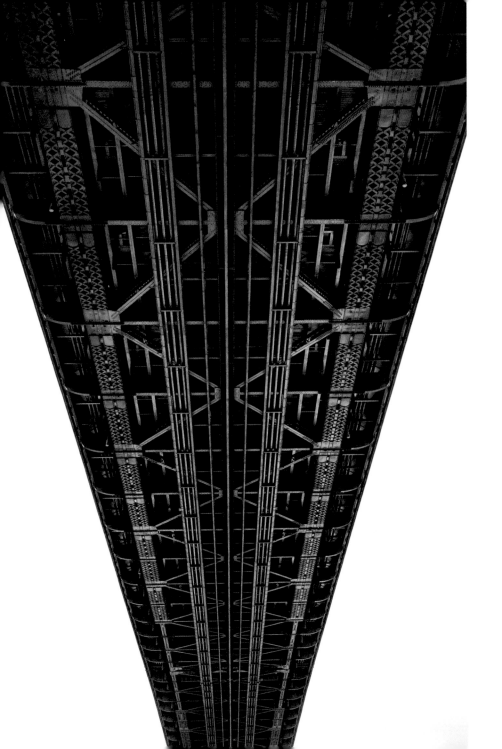

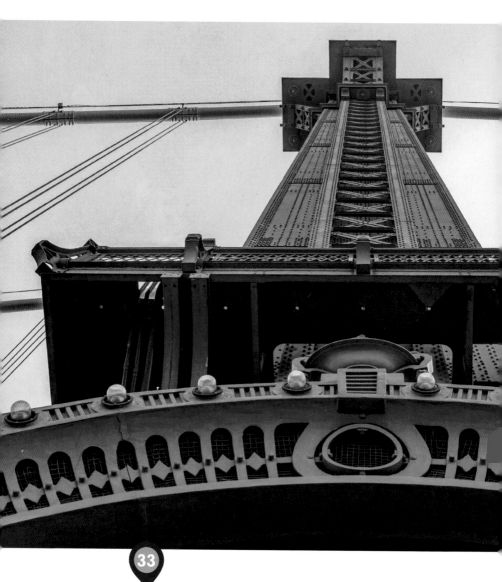

33

© Olimpio Fantuz
Location: **Manhattan Bridge**
Camera: **Canon 5D Mark II**
Lens: **24-70 2,8 LII**
Exposure: **ƒ 8 • 1/100 sec • ISO 320**
Other Equipment: **Neutral Density Filter, tripod Gitzo Mountaineer**

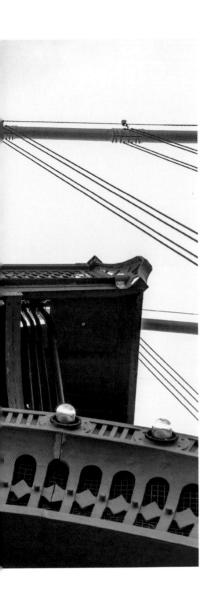

MANHATTAN BRIDGE

This photo is the sister of the last one. Two photos are still not a series, but clearly it could be the start of a study, an investigation that would remove these photos from the cauldron of chance—which has anyway actually given a great deal to photography—and bring them into the sphere of conscious effort. Here too, the tripod plays a vital part in taking a successful shot. Its steadiness saves time and gives you the confidence to create the perfect picture, especially in this case, since a small aperture was essential to keep the image sharp throughout.

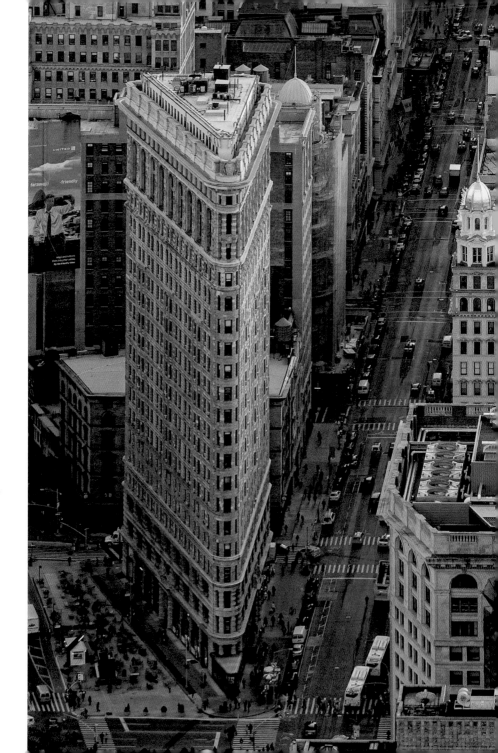

FLATIRON BUILDING

The search for geometries, patterns, and graphic qualities is part of the photographer's daily work, and a city like New York is an excellent testing ground. If you want to get clear and orderly images, three instruments are essential: a stand to keep the camera steady for long exposure times, as well as giving yourself time to stop and think about how to frame the shot, a detail that tends to be overlooked in the digital era; a tilt-swing lens to keep the lines straight, get selective focus, and enjoy a compositional potential that would otherwise be inconceivable; and a comfortable pair of shoes, which are essential if you are going to walk around and observe the subject from several possible angles, so as to understand its form and relationship to other elements in space. A photograph's defects often reflect failure to do the legwork!

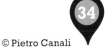

© Pietro Canali
Location: **Empire State Building**
Camera: **Canon 5D Mark III**
Lens: **EF70-200 mm ƒ/4L IS USM @ 116 mm**
Exposure: **ƒ 6,7 • 1/350 sec • ISO 800**

STATUE OF LIBERTY

Aerial photography is an evolving field with extraordinary potential, thanks to the development of drones and the ability to shoot from a helicopter, at prices within most people's budgets. In this spectacular shot, the photographer applied the rule of thirds to the letter, adapting it to the aerial view. The subject– the Statue of Liberty shot in all its splendor–does not occupy the center of the composition, but the lateral axis of the three into which the scene is ideally subdivided vertically.

35

© Antonino Bartuccio
Location: **Liberty Island**
Camera: **Canon 5D SR**
Lens: **35 mm**
Exposure: **ƒ 4 • 1/200 sec • ISO 1600**

COMPOSITION RULE OF THIRDS

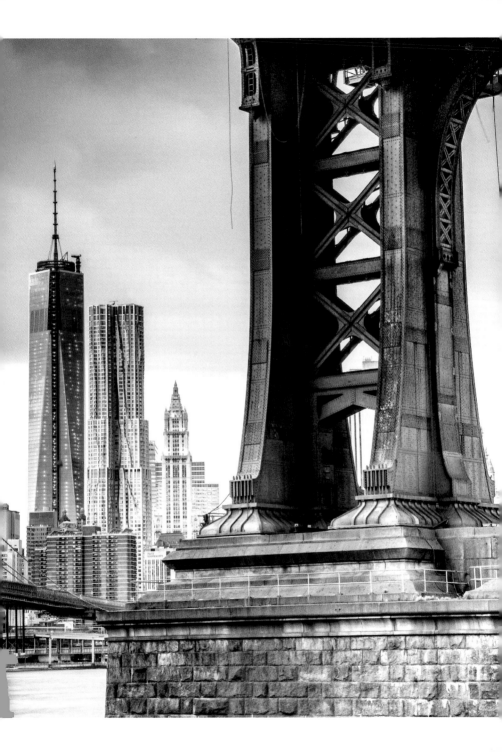

MANHATTAN BRIDGE

A telephoto lens often helps isolate subjects and geometries. In this case, the photographer has ideally divided the scene with three vertical lines, laying the main subject, the statuesque pylon of the Manhattan Bridge, along the outer line, while on the left emerge the new buildings on Wall Street. The synthesis is created by the related color harmonies, the bluish reflections on the piers echoing those on the skyscrapers, and the mellow light that softens what would be a somewhat aggressive scene if the sun was shining. Here, again, a tripod is important to place each object exactly where you want it, and the closure of the diaphragm makes the view more natural and three-dimensional. The result is an image that reflects the timeless rules of classic photography.

36

© Davide Erbetta
Location: **Manhattan Bridge**
Camera: **Canon EOS 5D Mark II**
Lens: **Canon 24/105 @ 84 mm**
Exposure: **ƒ 20 • 3,2 sec • ISO 160**
Other Equipment: **Graduated filter**

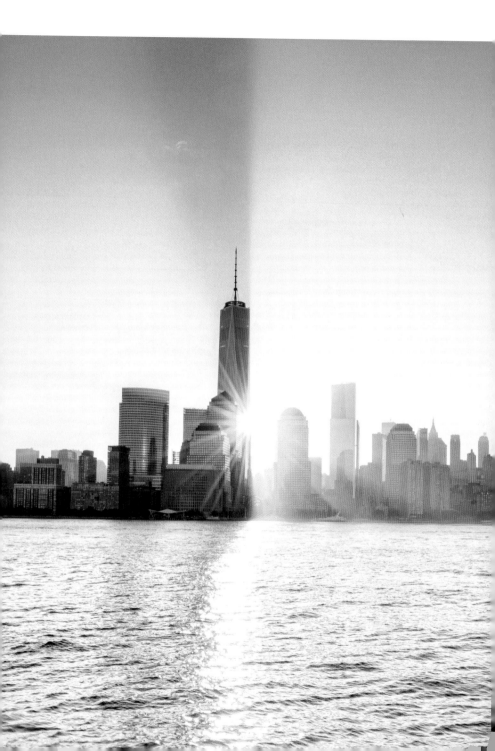

LOWER MANHATTAN SKYLINE

In ordinary circumstances, this composition could be dismissed as simply too symmetric, but this shot is made extraordinary by the rising sun, which has yet to clear the Manhattan skyline, and it throws a shadow from the City's iconic new skyscraper up into the sky. We see that shadow projected onto the morning mist, just the way that Gotham City's Bat-signal pierces the night sky. In this shot, the new day's sun flares around the edge of the Freedom Tower, a symbol of new beginnings.

37

© Justin Foulkes
Location: **Lower Manhattan**
Camera: **Nikon D800**
Lens: **24 mm**
Exposure: *f* 14 • 1/20 sec • ISO 100

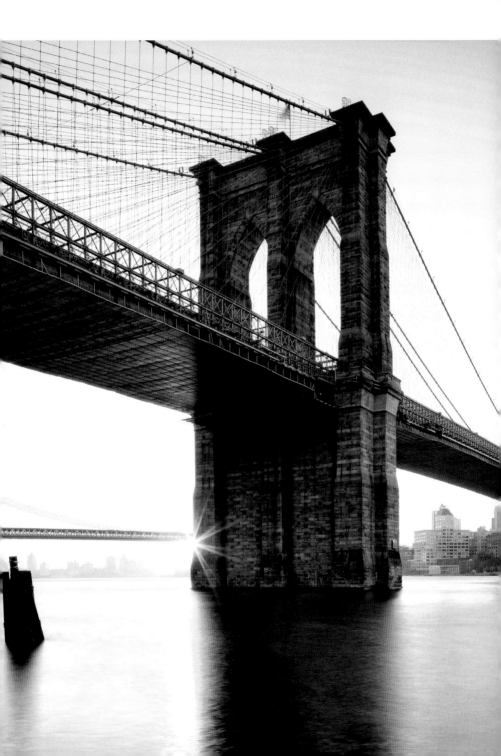

THE BROOKLYN BRIDGE

New York may well be a paradise for photographers, but when you decide to take that extra step, to explore ways to create a different or better kind of photo, when you want to raise your game and take part in the global free-for-all of photography as a creative achievement, then the rules are different. Few people know it. This picture would strike most people as rather banal, but actually it's simply wonderful. Everything is in its place: the rules of composition are respected, the lines of perspective clearly visible, the bridge statuesque, the water silent, the sunlight hesitant, yet dominant as always, and the chromatic balance perfect, with shades of color all the more modern for being vintage. With so much effort and so much passion. Bread and butter photography.

38

© Massimo Ripani
Location: **Brooklyn Bridge**
Camera: **Canon EOS-1Ds Mark III**
Lens: **TS-E24mm ƒ/3,5L II**
Exposure: **ƒ 14 • 25 sec • ISO 100**

COMPOSITION RULE OF THIRDS

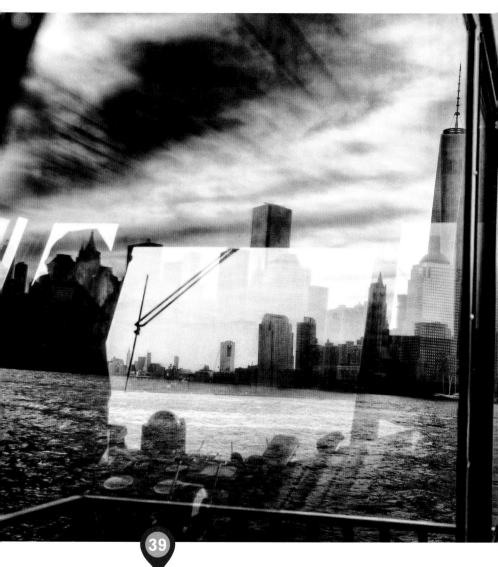

39

© Antonino Bartuccio
Location: **Hudson River**
Camera: **Canon 5D Mark II**
Lens: 24-105 mm @ 35 mm
Exposure: ƒ 8 • 1/250 sec • ISO 100

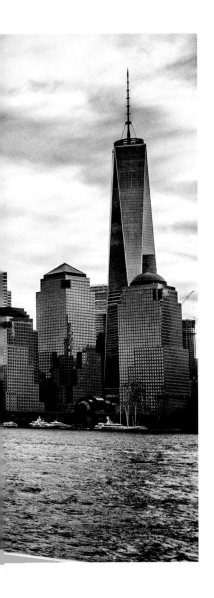

HUDSON RIVER

A grey day, the rippling waters of the Hudson, aboard the ferry from New Jersey chugging back to Manhattan. This is a hackneyed view; it might seem really hard to tweak it into life. Then all at once, like the images multiplying in a kaleidoscope, a reflection appears in the glass, with the phantom of the captain, the bridge of the ferry, and the city shattered into a thousand fragments mirrored in the windows.

And if two-thirds of the picture almost pay homage to surrealism, the remaining third to the right lives by contrast in a motionless serenity. This type of picture takes special training, or, if you like, the "third eye," the one that looks at things askew, recording details the other two see yet fail to capture.

YELLOW TAXI CAB

A yellow cab, the epitome of NYC. But it is the other elements that are evoked in the photo, starting from the complete blur. As an image stored in our collective memory, we instantly recognize the taxi without seeing it. The yellow suffices to conjure it up. Then who is the man seen in profile? At first he looks like the seated passenger, but then we realize he isn't. It's the reflection of a passerby perfectly framed in the glass-fronted buildings by gaudy advertisements and the busy street, with all the force of a fragment of memory, an image in a dream or a movie. An instant later and that image would be gone forever.

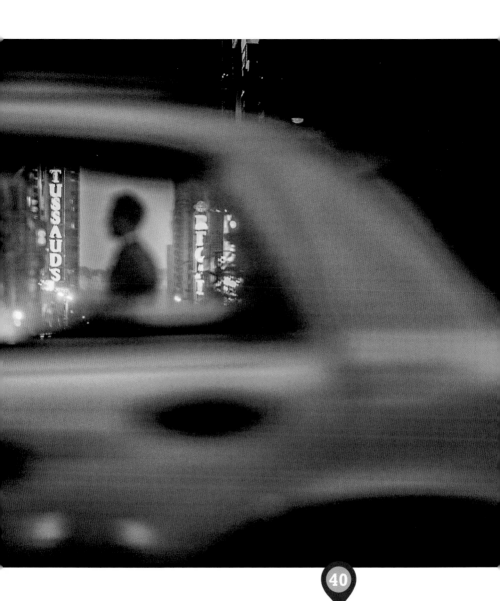

© Giordano Cipriani
Location: **Times Square**
Camera: **Canon EOS 400D Digital**
Lens: **200 mm** f/**2,8 @ 119**
Exposure: f **2,8** • **1/30 sec** • **ISO 800**

HUMAN STATUE OF LIBERTY RESTING IN TIMES SQUARE

Who would have thought it possible to bring together three such different women in a single shot? The model in the poster, the woman in the foreground, and the mime dressed up as the Statue of Liberty, looking a bit jaded and sad.
When the photographer decided to break all the rules, perhaps he had in mind Robert Frank's legendary series *The Americans*, a deck of tarot cards, or a comic strip. He certainly created a unique and moving photo. Street photography is a continual challenge for some; for others it's an insoluble and therefore uninteresting puzzle. The fact remains that the most intriguing situations, those that succeed in telling a story rather than simply representing it, are the most unexpected and are often hidden just around the corner.

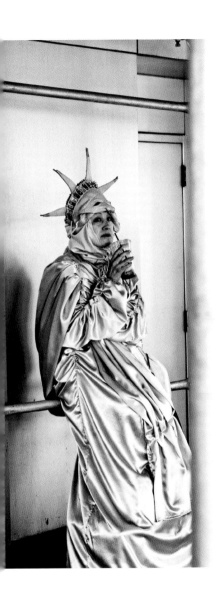

© Massimo Ripani
Location: Times Square
Camera: Canon EOS 400D Digital
Lens: Canon EF 24-70 f2,8L II USM @ 70 mm
Exposure: f 4,5 • 1/60 sec • ISO 100

APPLE STORE GLASS STAIRS

By traditional photographic logic, this image should simply not exist, because that day the light was poor, with an overcast sky and rain starting to fall.

What to do? Simple: stow your camera in your bag and scour the malls for bargains! But bucking the conventional approach often wins the juiciest prizes. Going down to the basement in the crystal lift materializes a world turned upside down, a fascinating interplay of transparencies. Here is a New York never seen before, emerging from the depths, forming an almost abstract pattern, with upturned architectures and people moving frantically like ants. After a first attempt at freehand, the final photo was taken by placing the camera directly on the floor, with the timer set, to capture an even wider view.

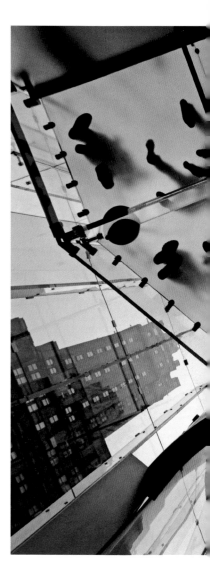

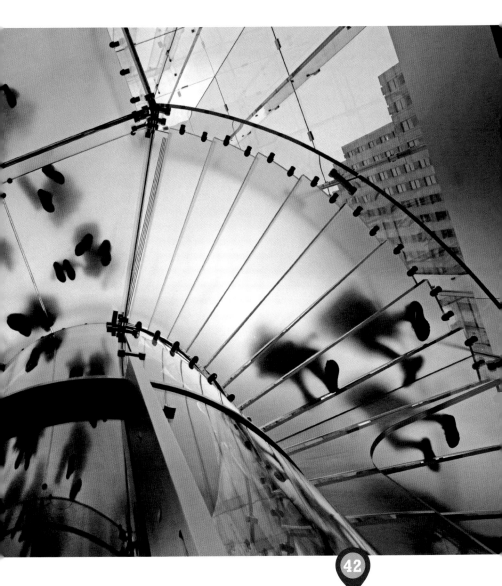

42

© Gabriele Croppi
Location: **Fifth Avenue, Apple Store**
Camera: **Canon EOS 5D Mark II**
Lens: **Yashica 21 mm**
Exposure: *f* 4 • 1/320 sec

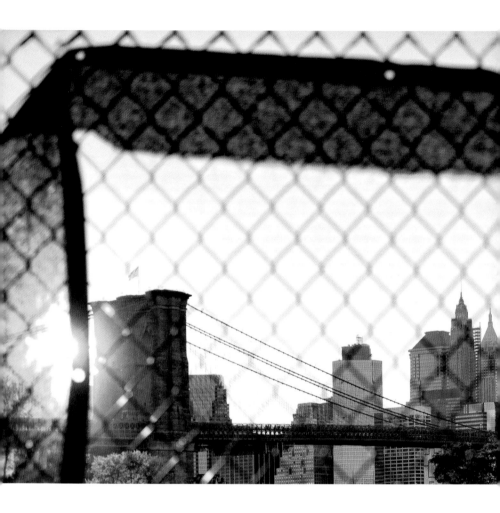

THROUGH THE NETTING

Sometimes a little ruse makes all the difference between a commonplace photograph and one with a character. Framing is a consummate technique to focus attention on the subject. In this case it only took a wire fence, the kind used for road works, to differentiate the two planes, the foreground and the metropolis. The blurring effect heightens the screening function of the netting. The framing of the shot and the monochrome range of the picture immediately conjure up a certain image of seventies New York, with movies

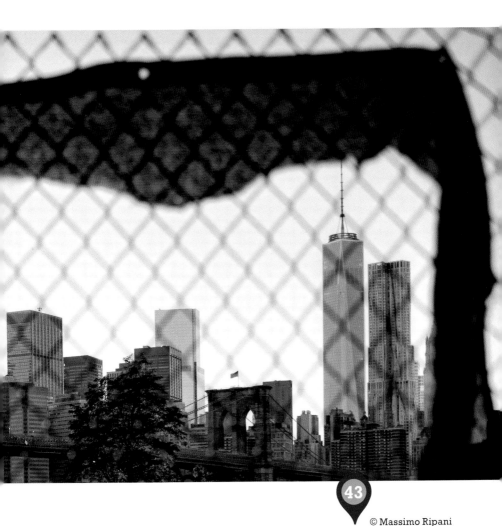

43

© Massimo Ripani
Location: **Manhattan Bridge**
Camera: **Canon EOS-1Ds Mark III**
Lens: **TS-E45 mm f/2,8 @ 45,0 mm**
Exposure: f 3,5 • 1/640 sec • ISO 100

about gangs and goodies and baddies chasing each other. But once again it is the mind that guides the shot, with the eye working in support.

Going out when you already know what you're looking for: this is the key to getting a shot like this.

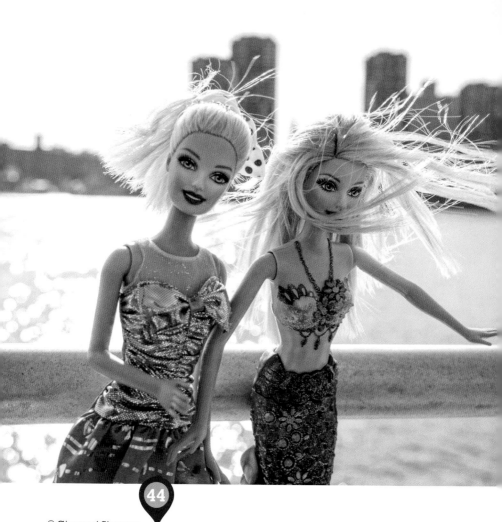

© Giovanni Simeone
Location: **East River Ferry**
Camera: **SONY ILCE-7R**
Lens: **FE 24-70 mm F4 ZA OSS @ 33 mm**
Exposure: *f* 6,3 • 1/1000 sec • ISO 125

BARBIE ON WATERWAY'S EAST RIVER FERRY

Here was a unique opportunity, absolutely unmissable. On the East River Ferry, the public service taking thrifty commuters and tourists from 34th Street to Pier 11 on Wall Street, calling at Williamsburg and Brooklyn, two little girls are playing with their Barbies. The Manhattan skyline forms the backdrop. Without waiting even a second, just grab the camera and shoot in bursts, hoping to get one with their hair blowing in the wind in a way that looks correct. The wide-open diaphragm isolates the action and adds the appropriate touch of glamour. The unconventional and imperfect cropping of the picture adds a touch of spontaneity often lacking in professional photographs but common on the social networks. Spontaneous, unexpected, complete chance and a joyous photo.

ART DECO DETAIL

The photographer liked the way the sun was hitting this art deco street cover near the Rockefeller Center. It is a simple image, easy to miss as you're walking around the city, but it's one of those details that helps to build an impression of a place, and these are just as important as the big pictures of a skyline and busy streets. He composed the image to keep the lines and graphic elements balanced in the frame. It was shot on manual, exposing to keep detail in the highlights, which was probably about a stop-and-a-half under what the camera was metering.

A vignette was added in post production to balance the image a little better and to allow the eye to concentrate on the subject.

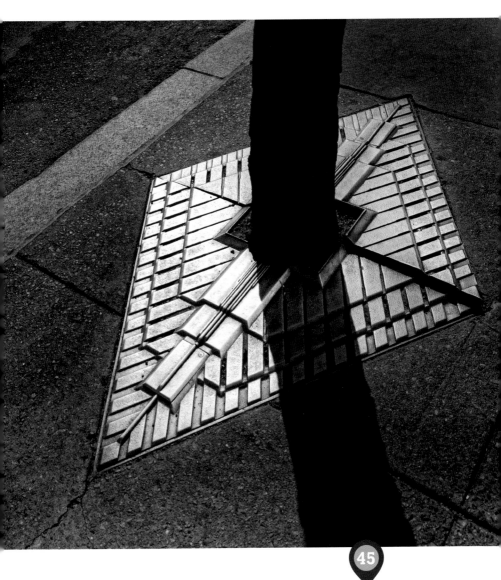

Location: **West 50th Street / Rockefeller Plaza**
Camera: **Nikon D800**
Lens: **Nikkor TS 24 mm, *f* 3,5**
Exposure: ***f* 5,6 • 1/1250 sec • ISO 100**

REMEMBRANCE

This is one of those places where
a photographer could easily feel trapped
and baffled. Crowds of visitors, barriers,
security checkpoints, and, even worse,
the light screened by all the buildings,
all combine to interfere with the task
of creating an image expressing the
solemnity, significance, and atmosphere
of this iconic place. Hence the idea of a
close-up, a detail to evoke its general
meaning. The open diaphragm and the
subject occupying the foreground greatly
reduce the depth of the field and bring out
the importance of the action taking place,
a young hand tracing with one finger the
inscribed name of one of those who died
on September 11. The natural color and
absence of processing is a deliberate
way to emphasize the solemnity of the act
and preserve the innocence of the child's
gesture. But what if the photographer had
planned it all coolly beforehand?

46

© Giovanni Simeone
Location: **National September 11
Memorial & Museum, Manhattan**
Camera: **SONY ILCE-7R**
Lens: **FE 24-70 mm F4 ZA OSS @ 54 mm**
Exposure: **ƒ 5,6 • 1/400 sec • ISO 320**

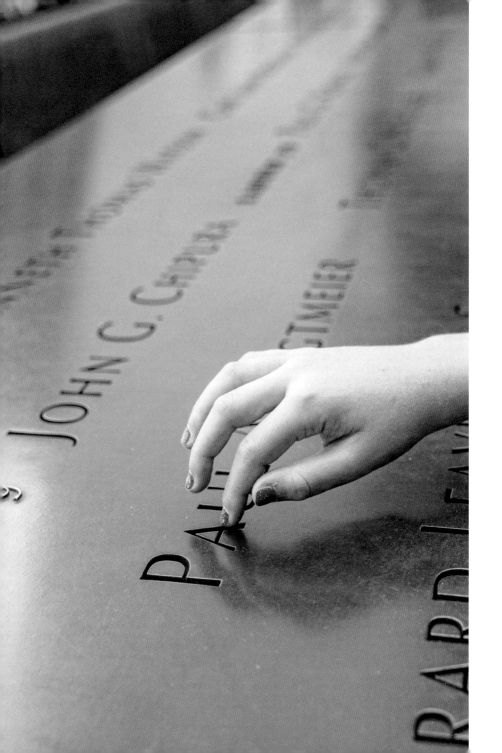

PRINCE STREET STATION

The New York subway offers an inviting refuge, especially when it's raining or the light is poor. You don't have to travel far and wide. To get memorable shots just choose a few stops at random and a story will present itself to your lens. And it can be an inexhaustible source of inspiration thanks to the endless stimulus from the work of famous photographers and directors, which you should always keep in mind. In this case the focus is on these intriguing silhouettes applied to the tiles depicting people in movement along an endless dotted line. The open diaphragm results in background blur, and perspective lines heighten the impression of continuous movement represented by the figures in the foreground and the two people silhouetted in the background.

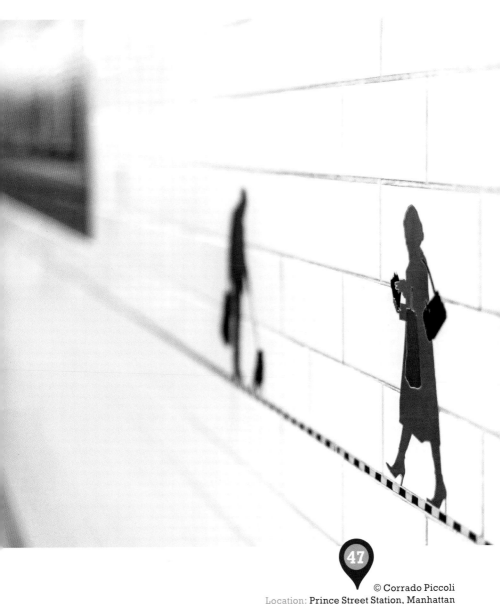

© Corrado Piccoli
Location: Prince Street Station, Manhattan
Camera: Nikon D600
Lens: Nikkor AF-S 50 f/1,4 G
Exposure: f 2 • 1/800 sec • ISO 1600

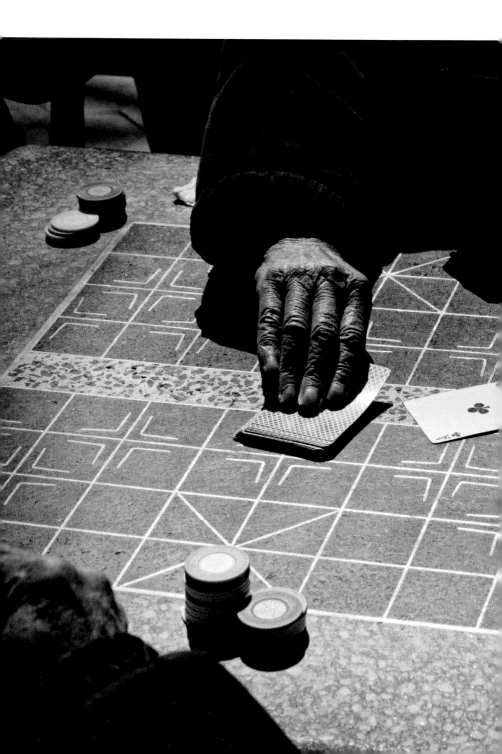

CHINESE WOMEN PLAYING CARDS

Don't be afraid to probe and move close to your subject to get a convincing composition. Eliminate the superfluous. You can create a stunning photograph by focusing on the real point of interest. The meaning of this photo, set in an ideal frame, can be captured at a glance. The close-up picks on the decisive gesture of the hand taking a card from the deck. The effect is heightened by the beautiful surface of the table and the stacked chips creating bright spots in the bright spring sunshine. This image was taken in Columbus Park, known as Chinatown, one of the best places to walk and spend time photographing. Though there is gentrification, much of the atmosphere of old New York can still be found. The park is a gathering place for senior men and women of Chinese descent. There is usually a band that plays traditional Chinese music, and there are fortune tellers.

48

© Keith Goldstein
Location: **Columbus Park, Chinatown**
Camera: **Panasonic Lumix DMC - G1**
Lens: **Panasonic Lumix G 14-45**
Exposure: *f* 8 • 1/250 sec • ISO 400

COMPOSITION CLOSE-UP

EXPO SURE

EXPOSURE

take control of
aperture and
shutter speed,
and tame the
light

It's all too easy to set the camera to autopilot, leaving ourselves free to focus on light, graphic composition, and choice of lens, but to do so leaves powerful creative tools in our box and delivers a formulaic world view set by the camera. That's often just fine, but as artists, we should manage our camera's exposure of the image, because exposure is much more than an appropriate combination of lens aperture and shutter speed to capture a moment in time. Exposure is about controlling the light, with just two variables: lens aperture and shutter speed.

By taking control of aperture and shutter speed, we start to tame the light to do what we want.

A wide aperture delivers a shallow depth of field, which means we can focus our audience's attention to a specific point in our photograph by blurring distracting details. Conversely, a small aperture brings

more of our image into sharp focus.
With shutter speed we control the
way we record and communicate
motion in our still image, by freezing
moving objects in our frame with a
fast shutter speed or deliberately
allowing them to blur as they traverse
the camera's field of view during
longer exposures.
Deliberate decisions over blur
and focus can make exposure into
another compositional tool and help
us tell tales about the busy city.

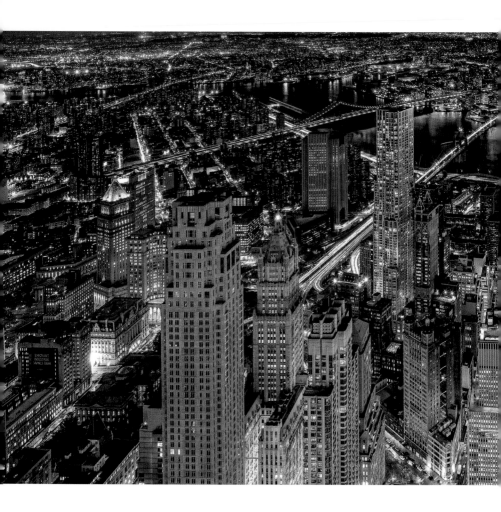

ONE WORLD
OBSERVATORY

From the observatory of the Freedom Tower, this view of The Big Apple
stirs new emotions still barely exploited by photographers (it only opened
in 2014). It might seem like a fabulous opportunity to have the highest
360-degree view in the city all to yourself, but there are difficulties: the
Observatory is all glass, so it is immersed in a sea of troublesome reflections.
But here's a solution: shoot with a miniature 15 cm-tripod, with a wide-angle

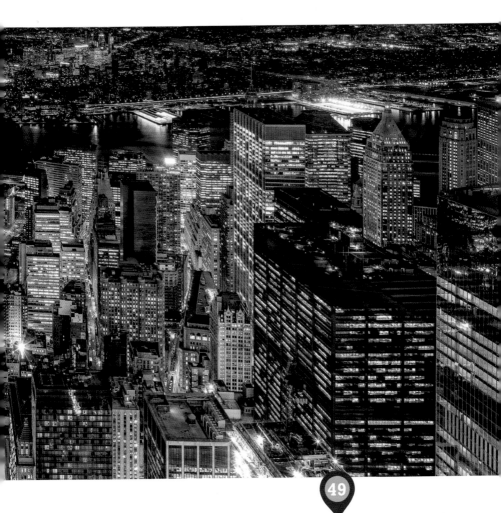

Location: **One World Observatory, Manhattan**
Camera: **Canon 5D SR**
Lens: **TS-E17 mm** f**/4 L II**
Exposure: f 9 • 30 sec • ISO 100

shiftable lens resting against the glass, and with the camera covered by a cloth (a jacket will do) to eliminate reflections.

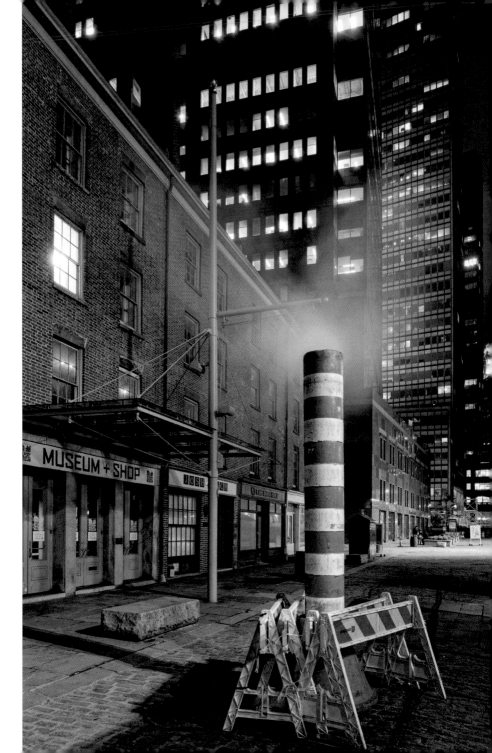

SOUTH STREET SEAPORT

South Street Seaport is one of the continuously changing parts of Manhattan, where old brick buildings abut modern skyscrapers and nineteenth-century New York merges with the modern city. Night heightens these contrasts and every corner becomes a discovery. You see it in this photo, where the work going on, the smoke coming out of the odd-looking–for newcomers to New York–red and white funnel, the low brick building and skyscraper in the background, all of them classic icons of the metropolis. The long exposure time and the deserted spot make this little-known corner of Manhattan even more fascinating.

© Arcangelo Piai
Location: **South Street Seaport**
Camera: **Nikon D800E**
Lens: **PC-E Nikkor 24 mm $f/3,5$ @ $f/11$**
Exposure: **f 11 • 13 sec • ISO 125**
Other Equipment: **Graduated filter**

TIMES SQUARE

Times Square is the very epitome of the famous phrase "the bright lights of New York": gaudy neon signs, scrolling messages, a giddy multitude wandering almost aimlessly, blinded by so much light. It seems easy to create a stunning nocturne in Times Square.

Here the emphasis was laid above all on the contrast between the darkness of the night and the artificial lights.

The striped effect is achieved with slow shutter speeds and by the in-out telescoping movement of the zoom. A tripod is vital in these cases, and care over filling in the shot with colors and forms lends awareness to the image.

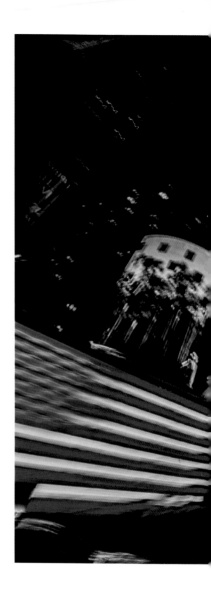

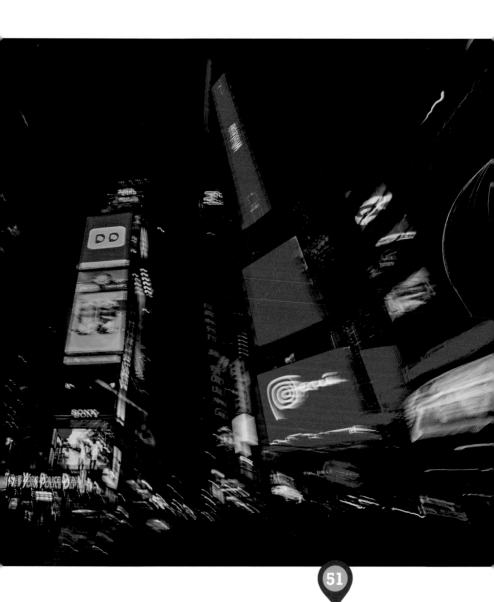

© Giordano Cipriani
Location: **Times Square**
Camera: **Nikon D700**
Lens: **14,0-24,0 mm** f/2,8 @ 14
Exposure: f 22 • 10,4 sec • ISO 200

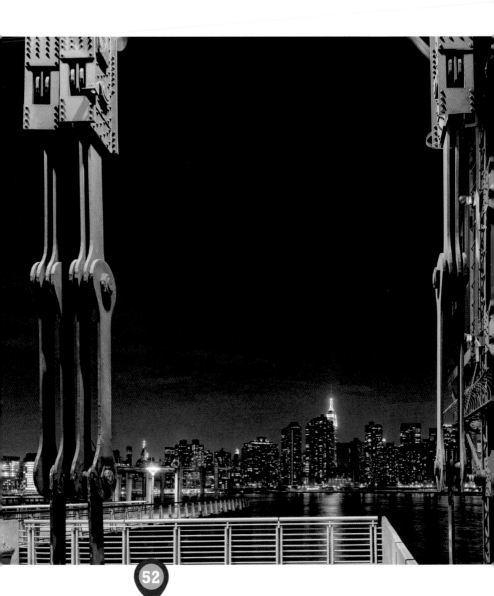

© Claudio Cassaro
Location: **Gantry Plaza, Queens**
Camera: **Nikon D800**
Lens: **24 mm PC-E**
Exposure: **ƒ 11 • 3 sec • ISO 800**

GANTRY PLAZA

Long Island City is one of the most vital parts of New York City. In a few years, from being a seedy neighborhood, it has changed amazingly, becoming perfectly safe even at night. The whole riverfront has been restored with walks and parks, offering unprecedented views of Manhattan. Of course, there are still fascinating old buildings and brownfield sites, which are a feature of Queens and Brooklyn. These derelict industrial facilities are a perfect place to experiment with nighttime shots.
The only technical advice you need is to be sure you have a good tripod and to keep the ISO low so as not to have to struggle with the "digital noise" of the sensor once you're back home.

EXPOSURE NIGHT

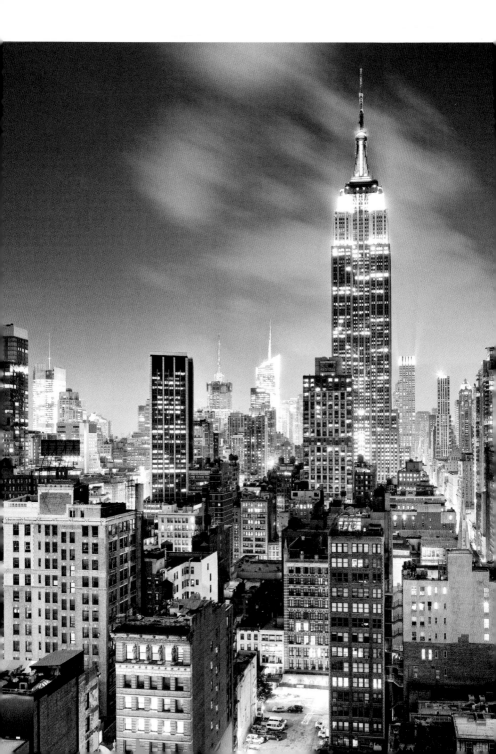

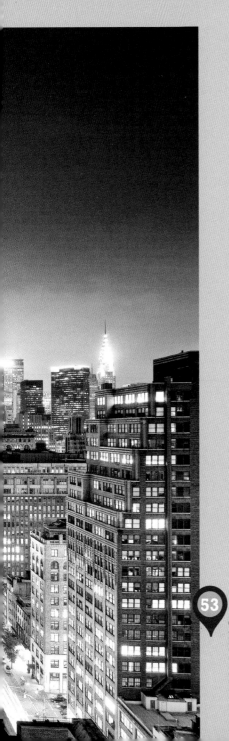

FROM 230 FIFTH ROOFTOP BAR

This photo was taken from the terrace of one of Manhattan's trendiest bars, with an unrivaled view over the city. When taking pictures from rooftops of hotels, bars, and tourist attractions, it's worth bearing in mind that tripods may well be banned, so you have to equip yourself with something to keep the camera stable. In this case it was a pocket tripod set on the balustrade of the terrace, to take advantage of the long exposure times needed for a night shot and get the slight fuzziness on the cloud that forms the backdrop to the subject, the Empire State Building in all its majesty. There's no denying it—this is a timeless, classic image, as even the most hardened modernist photographer will admit.

53

© Luigi Vaccarella
Location: 230 Fifth Rooftop Bar, Manhattan
Camera: Canon EOS 5D Mark II
Lents: TS-E 24 mm $f/3,5$L II @ 24 mm
Exposure: f 9 • 30 sec • ISO 100

EXPOSURE NIGHT

121

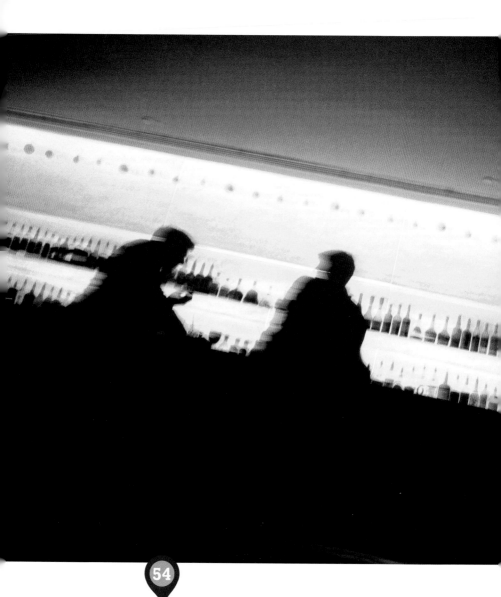

© Giovanni Simeone
Location: **Times Square**
Camera: **Sony NEX**
Lens: **35 mm**
Exposure: *f* 2,8 • 1/10 sec • ISO 800

COCKTAIL BAR

Among the most classic shots in films about New York, there are the dialogues set in cocktail bars. A Martini or Cosmopolitan is a must before dinner, and the idea behind the photo is to create an iconic image of a widespread custom. The impossibility of taking pictures of people without their consent and the fear of receiving a brusque no! from the bar owners have practically made it compulsory to take a blurred photo that evokes an idea rather than recording it. The scene is simple and immediate. The high ISO and controlled movement make this a symbolic photo and highly representative of a certain kind of New York scene, while a semi-amateur camera will help you pass unnoticed.

CITYSCAPE

The idea of turning Manhattan into a toy town is a technical decision that draws on the established imagery of fine art photography, seeking to surprise the viewer's eye by disorientation so it is no longer able to focus on what it habitually sees. Using a tilt-and-shift lens, which lets you take images with large focal areas, typical of a close-up, you get unorthodox photos, instantly likable, funny, and unexpected. In the chaos of the concrete jungle of Midtown, the attention rests on a light line of optical focus, while the blurred areas bring out the importance of the principal subject. Keeping the diaphragm well open can heighten the effect. This is worth remembering.

55

© Maurizio Rellini
Location: **Rockefeller Center**
Camera: **Canon 5D Mark III**
Lens: **45TS**
Exposure: *f* **2,8 • 1/500 sec • ISO 400**

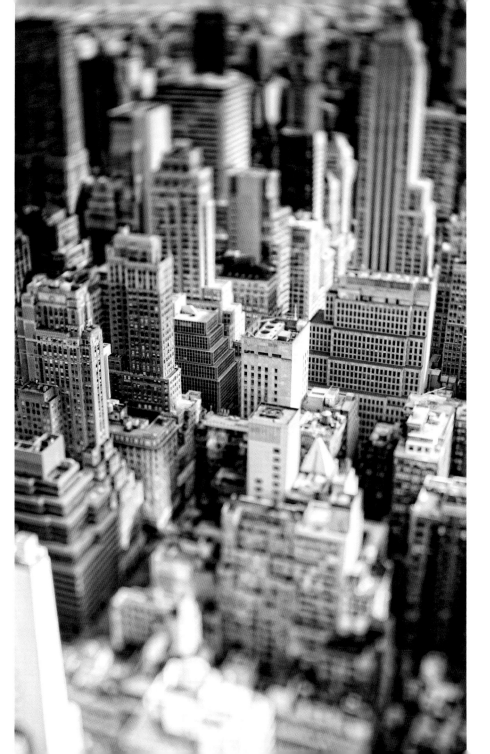

EMPIRE STATE BUILDING

The verticality of a subject like the Empire State Building is proverbial. For many years it was the world's tallest building and the undisputed symbol of Manhattan. Hence the choice of a manual blur with a perfectly vertical movement is just right to give the image a unique atmosphere. This kind of technique can be adopted with long exposure times, from 1/30 or longer, and of course the speed of the moving subject affects the final result. The pictorial effect of the blur is almost ever appealing, but, as always, experience should curb the eagerness of the novice.

56

© Massimo Ripani
Location: **Top of the Rock, Rockefeller Center**
Camera: **Canon EOS-1Ds Mark III**
Lens: **TS-E24 mm *f*/3,5L II**
Exposure: ***f* 16 • 0,3 sec • ISO 50**

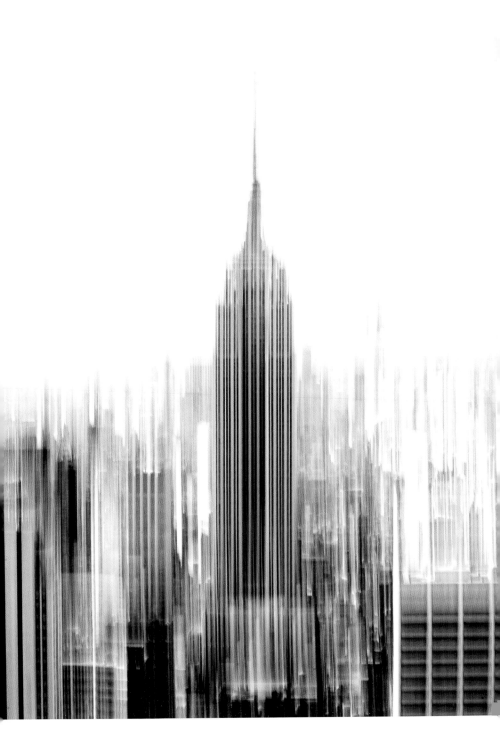

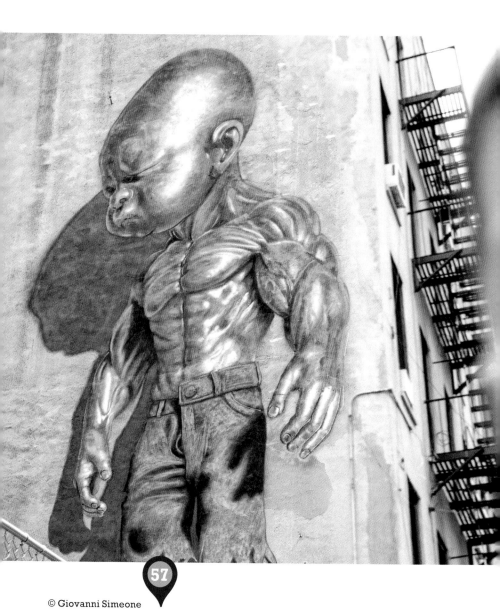

© Giovanni Simeone
Location: Little Italy, Manhattan
Camera: Canon 5D
Lens: 24-105 F4
Exposure: ƒ 5,6 • 1/125 sec • ISO 125

TEMPER TOT

Just face it: you have no hope of getting the full cooperation of a five-year-old in New York to take his picture in the street. It will only put a strain on both the father and the photographer, and so much the worse if he is one and the same person. With a little luck, the alternative cropped up in front of Ron English's fabulous mural *Temper Tot* in Little Italy. The photo plays naturally on the reflections between the expressions of the two children, one painted and the other in real life. The crossness of the latter at being photographed yet again, barely veiled by the soft focus, is the perfect synthesis of the work.

* By their nature, urban murals and graffiti are impermanent. The publisher apologises if the City of New York painted this wall.

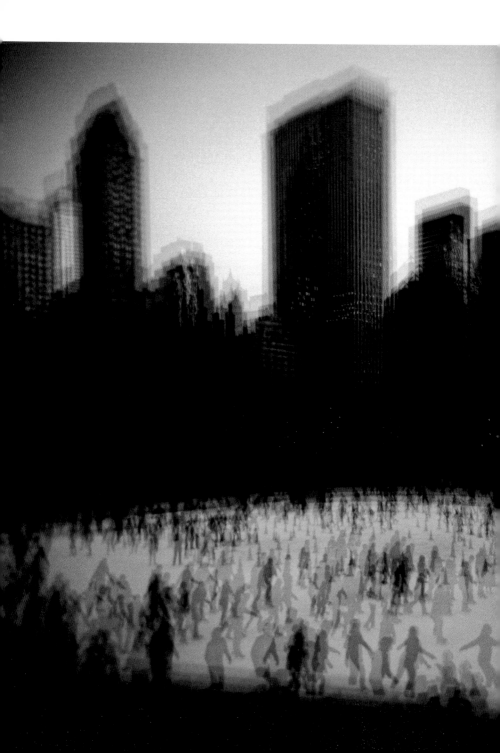

WOLLMAN RINK

It is a late winter afternoon in New York City. The sun goes down, and people are having a good time in and around the ice rink in Central Park. As simple as it gets. But instead of taking the usual picture postcard of the park ... be inspired by the great German artist Gerhard Richter. While he works on soft-focus paintings seeking to obtain photographic effects, you can get the same effects directly with your camera, by taking a photo with overlapping shots.
Remember to properly calculate the exposure time based on how many shots you want to overlap.

58

© Christophe Boete
Location: **Central Park**
Camera: **Holga camera**
Film: **Kodak 160 VC**
Exposure: **multiple exposures**

EXPOSURE BLUR

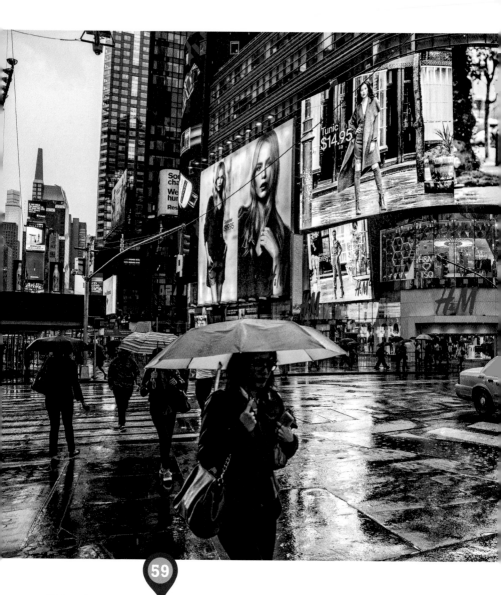

59

© Antonino Bartuccio
Location: Times Square
Camera: Canon 5D Mark II
Lens: 24-105 mm @ 24 mm
Exposure: *f* 5,6 • 1/250 sec • ISO 320

TIMES SQUARE IN THE RAIN

Don't be put off by a spot of bad weather. Rain creates an atmosphere and heightens the emotional intensity of a shot. Reflections in the water, contrasts of light, and flat skies are a real spur to creativity. Times Square, with its endlessly varied people and seemingly inexhaustible energy, is a natural stage that changes every second. The magic of lights, neon signs, and billboards that hammer away night and day is increased by the rain, which creates special color effects. Among the thousands of busy people striding to offices, one woman stands out with her yellow umbrella, echoing one of the Big Apple's most famous icons: the yellow taxis.
A life like so many others here becomes a story to be told.

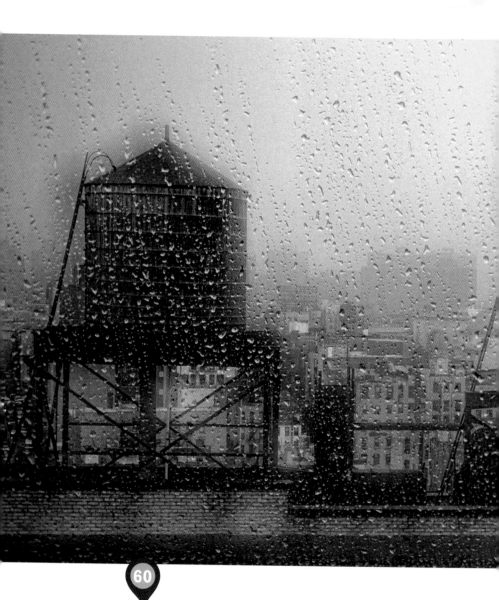

© Christian Heeb
Location: **Downtown Manhattan**
Camera: **Nikon Film Camera**
Lens: 70-200 mm *f* 4
Exposure: *f* 11 • 1/40 sec • ISO 100

DOWNTOWN MANHATTAN

Why not treat the rain pelting on the windows as a cheap, natural filter for your photographs? It's not hard: just wait for a shower and position yourself behind a large window. The water will design unpredictable patterns on the windowpane, and the moisture will do the rest, fogging the glass and creating mysterious mists.
This picture depicts the water towers, landmarks for residents and tourists, gigantic tanks with the classic cylindrical shape resembling scaled down grain silos. In this way you double the theme of water.

MADISON SQUARE PARK WITH SNOW

In a scene in the movie *Smoke* (1995), scripted by Paul Auster, the protagonist Auggie Wren confesses proudly to Paul he's taken more than 4,000 photos of the same subject, the corner between Third Street and Seventh Avenue at eight o'clock in the morning. "They're all the same, but each one is different from every other one. You've got your bright mornings and your dark mornings. You've got your summer light and your autumn light. ... You've got your people in overcoats and galoshes, and you've got your people in shorts and T-shirts. ... The earth revolves around the sun, and every day the light from the sun hits the earth at a different angle." Now, though the point being made is valid, we're not recommending this slightly maniacal attitude. We're simply suggesting you take advantage of every meteorological event, including snow and sludge, because it adds a new color that enhances the truthfulness of the photo and its grasp on a fragment of real life.

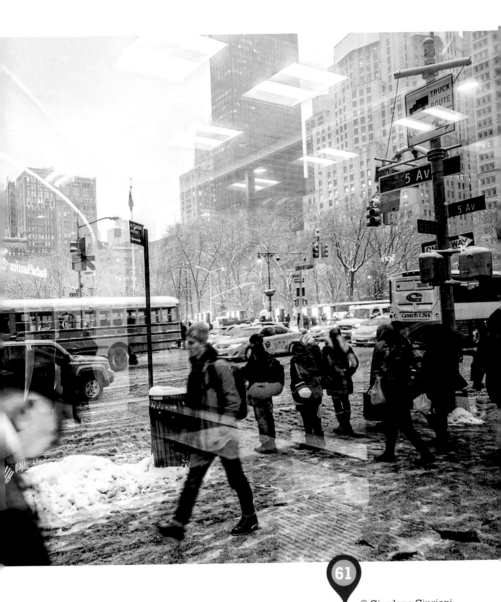

© Giordano Cipriani
Location: **23rd St and 5th Av at Madison Square Park**
Camera: **Nikon D7000**
Lens: **14-24 ƒ2,8 @ 24 mm**
Exposure: **ƒ 3,2 • 1/40 sec • ISO 500**

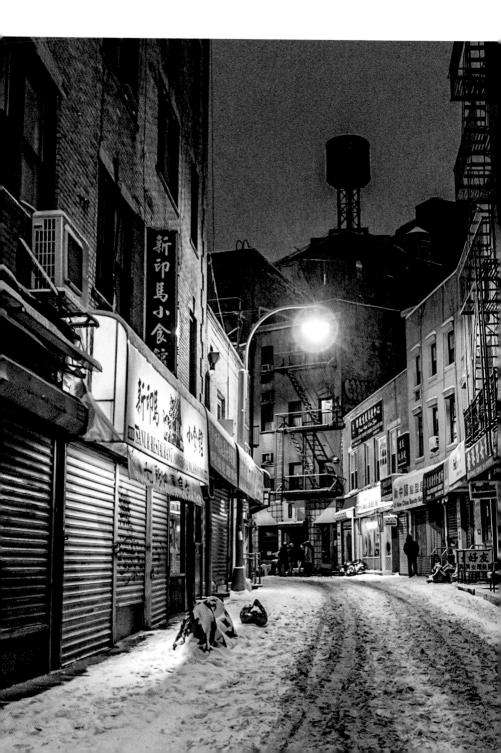

CHINATOWN

One of the few streets with a bend in Manhattan, Doyers Street is famed as "Bloody Angle," having been the site of shootings and hatchet murders. A narrow lane, it looks rather like the abandoned set of a gangster movie. Here we're in Chinatown, at nine o'clock on a night like any other. It must be freezing, with so few hardy souls to be seen on the street. What remains of this winter's day? A snow-covered road stained by car wheels and litter, a haunting sense of frost and suspension, heightened by the pale light at the center of the composition. Ever-present in a New York street scene are the water tower and the fire escapes, their ends cropped, leading into the unknown. Legend has it that a network of tunnels connecting the various buildings made for quick getaways.

62

© Giordano Cipriani
Location: **Pell St and Doyers St, Chinatown**
Camera: **Canon G16**
Lens: **6,1 (6,1-30,5 mm)**
Exposure: **ƒ 8 • 1/30 sec • ISO 640**

GAPSTOW BRIDGE, CENTRAL PARK

When it snows in New York, the photographer goes in search of perfect and immaculate whites on trees and skyscrapers. He knows at once where to find them.

For example, Central Park. There is a particular spot in the park that always offers a sense of tranquility, romanticism, and peace. This magical spot is the Gapstow Bridge, here glowing in the aftermath of a fierce snowstorm, subtly coated in the white of winter snow, almost symmetrically framed by trees and visited by beautiful ducks playing in the pond. It fills the senses as you reminisce over childhood Christmas times.

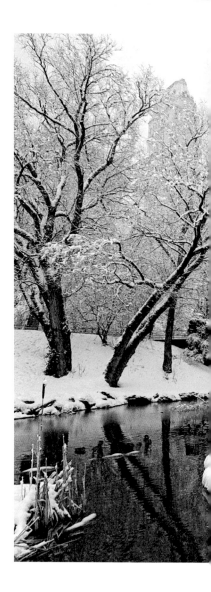

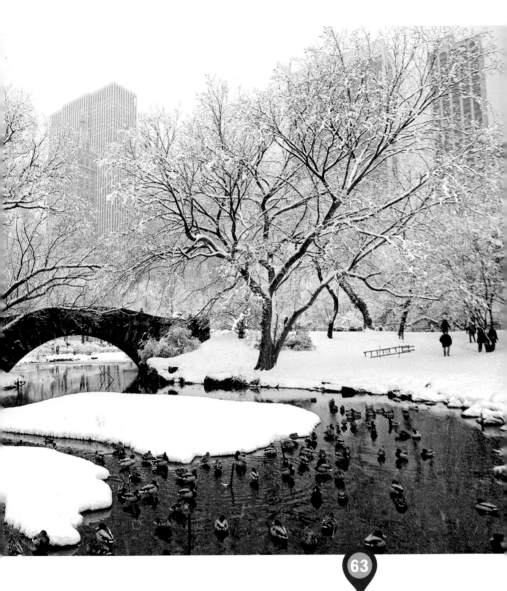

63

© Claudia Uripos
Location: **Central Park**
Camera: **Canon Mark II**
Lens: **17-40 mm**
Exposure: f 6,3 • 1/80 sec • ISO 160

SEEING

seeing comes
from recognizing
possibilities
within our scene.

Seeing is intimately entwined with composition, but while composition is largely about the graphic elements in our image, seeing is something less tangible. Seeing comes from recognizing possibilities within our scene; it's preparation and anticipation on one side, awareness and adaptation to circumstance on the other.

To research our destination and arrive with a shoot schedule and wish list is good, probably even desirable when we have limited time; but we must be relaxed, tuned into the rhythms of the city if we're to recognize the potential for memorable images as situations evolve between our four corners. Once we start anticipating the way a scene will develop, we instinctively find ourselves in the best place more often, for there's more to making memorable images on the street than simple blind luck.

When we combine preparation, anticipation, and on location decisions about how we want our finished image to look and feel, the photographer develops an important skill the professionals sometimes call "premagination", knowing what your image will be before you release the shutter. The best photographers use it every day, and it will make your work stand apart from the other photographers you rub shoulders with in New York or anyplace else.

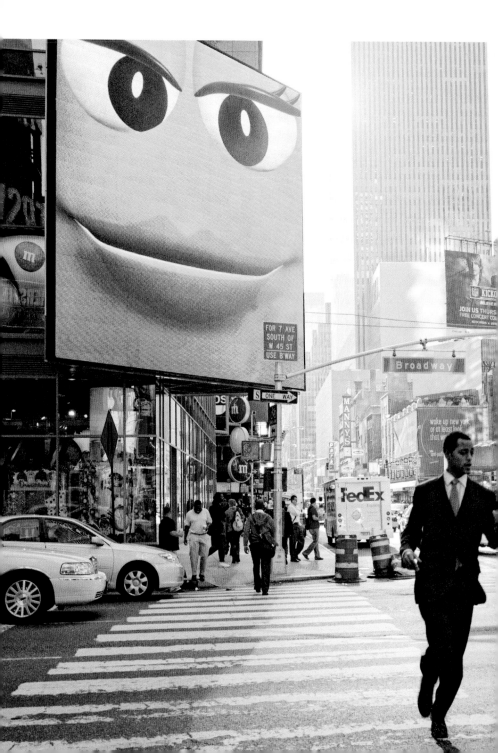

TIMES SQUARE

Times Square is a playground for any photographer, being endlessly intriguing and inexhaustibly stimulating. But an experienced photographer has to have the courage to go further and create a unique image, or at least one that is strikingly different. This shot meant waiting patiently for over an hour to create the perfect combination of the big yellow M&M's face, the taxi of the same color, and the passing of a single, well-dressed man.

The shot is seemingly simple, but based on perfect timing. Technically the photo was taken with a Mamiya6, ISO 160 negative film. It goes without saying that the real plus in this case was the patience to wait for the decisive moment to take a picture that had already existed for a long time in the form of an idea.

64

© Giovanni Simeone
Location: **Times Square**
Camera: **Mamiya6**
Lens: **80 mm** f **4**
Exposure: f **5,6** • **1/125 sec** • **ISO 160**
Negative film

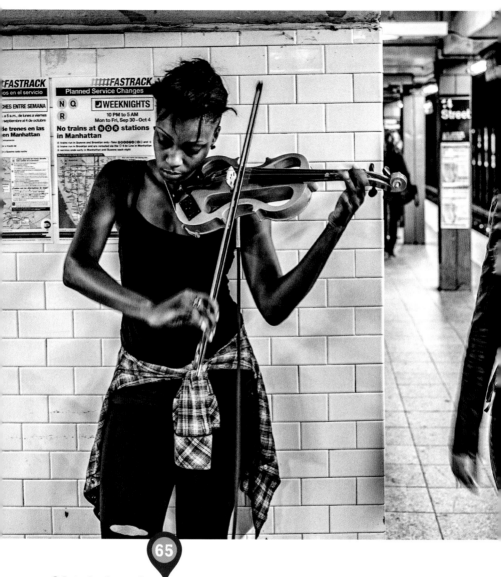

© Antonino Bartuccio
Location: **Subway, Manhattan**
Camera: **Canon 5D Mark II**
Lens: **EF35 mm ƒ/1,4L USM**
Exposure: **ƒ 3,2 • 1/15 sec • ISO 500**

SUBWAY

Take a good look at this picture and then ask yourself: where was the photographer? How could he get so close, without the two girls being aware of him? This is the silent reporter, invisible, patient, camouflaged against the tiles in New York's subway, one of those places that is a condensation of all the stories and feelings in the world. The one told in this shot narrates the moment when a pleasant blonde, standing out against the dark backdrop, is captivated by the intensity of the violin and turns to the splendid and energetic black musician, standing out against the light ground. Two lives, certainly very different, condensed into a single shot, black on white and white on black perfectly divided in two, with a high-contrast chiaroscuro evoking a slow tempo, echoing the thrilling note of the electric violin.

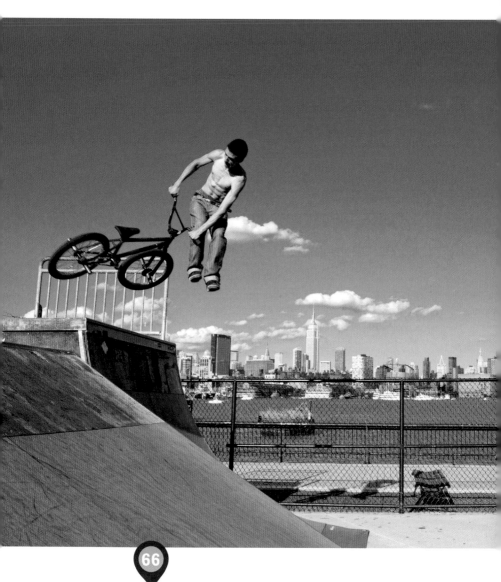

66

© Stefano Torrione
Location: **Castle Point Skatepark, Hoboken, NJ**
Camera: **Canon EOS 5D Mark III**
Lens: **EF24-70 mm *f*/4L IS USM @ 29 mm**
Exposure: ***f* 11 • 1/320 sec • ISO 200**

BMX BIKE AT CASTLE POINT SKATEPARK

Timing is everything in this photo. What Henri Cartier-Bresson called the "decisive moment," with the release button pressed just as the scene materializes in its most intense photographic incarnation. A good dose of anticipation and instinct are the key factors, as well as careful study of the locale and whatever is happening at the time— the biker flying off the ramp in this case. So keep your eyes peeled, ready to shoot when the decisive moment appears. And it won't be hard to find.

BARMAN AT RED ROOSTER

A moment of spontaneous joy, an engaging smile, the point of view that brings out the barman's gesture. How many shots did it take to get this perfect combination? Shoot. Wait. Shoot. Wait and shoot again. It takes time to capture the ideal moment. To avoid disappointment, remember the decisive moment may not occur that day. Come back the next day ... or try to stage-manage the photo you want. Repeatedly order the same cocktail, for example, and a good tip might win the barman's indulgence. What won't you do for a photo? Actually, reportage photography is a science, in which different elements combine, like promptness, friendliness, the ability to blend in and above all incredible acumen in being able to understand the way the action is developing even before it happens.

The technical dimension becomes secondary, so before you immerse yourself in a situation, set the camera settings and sensitivity to suit the scene.

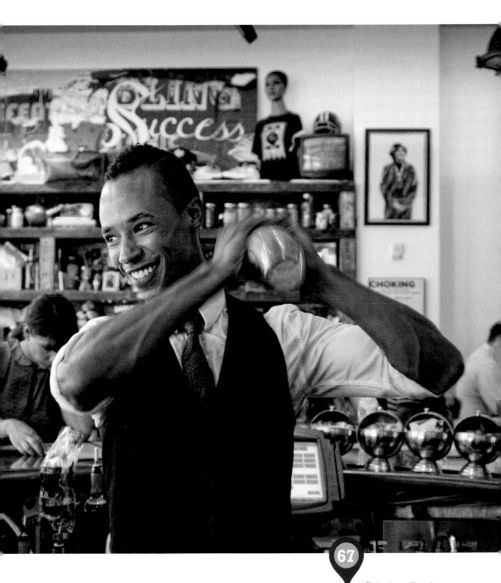

67

© Stefano Torrione
Location: **Red Rooster, Harlem**
Camera: **Canon EOS 5D Mark III**
Lens: **EF24-70mm ƒ/4L IS USM @ 38 mm**
Exposure: **ƒ 5 • 1/50 sec • ISO 800**

153

CONEY ISLAND

On the weekend New Yorkers go
to Coney Island for its beaches,
seafront walks, and its big
amusement park. It is an excellent
place to observe the varied
humanity that populates this
megalopolis. The very bravest,
or those who just want to get an
adrenalin rush, do bungee jumping,
letting themselves be shot into the
air tied to a rope.

The photo captures the sensation
of absolute freedom experienced
by this person, with arms spread
out like the wings of a bird in flight.
Technically it looks like an easy
picture. But controlling the exposure
to create a silhouette is always
delicate and should be done without
burning out the sky, so generously
underexposing it.

68

© Antonino Bartuccio
Location: **Coney Island, Brooklyn**
Camera: **Canon 5D Mark III**
Lens: **EF35 mm _f_/1.4L USM**
Exposure: **_f_ 4 • 1/1000 sec • ISO 100**

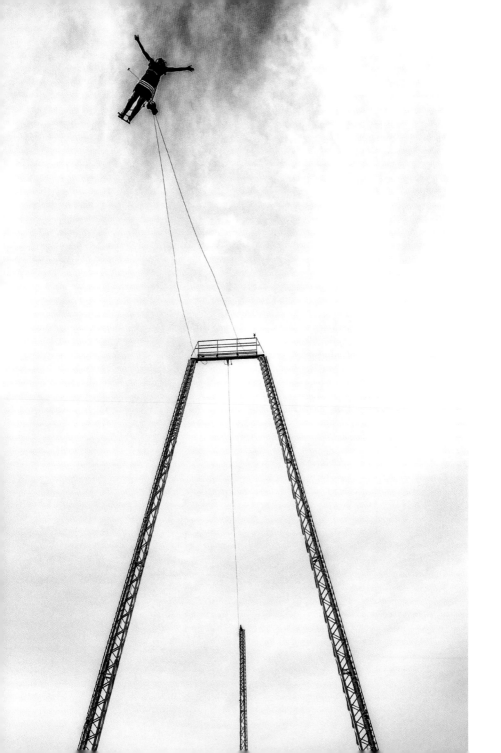

SELF-PORTRAIT WITH A STRAW HAT

New York's museums are a mine of inspiration for photographers. They have amazing architecture, famed artworks, and streams of visitors interacting with each other in ways that keep changing all the time. What makes the difference is knowing how to seize the moment when such an interaction becomes significant, as in this case.

Two visitors are admiring an earlier study of peasants painted on the back of Vincent van Gogh's famous *Self-Portrait with a Straw Hat* (1887). The key to the composition, which took a minute in all, was the symmetry between the two faces, cut in half by the canvas, and seemingly recomposed in the Dutch artist's magnetic gaze.

69

© Arcangelo Piai
Location: **The Metropolitan Museum of Art**
Camera: **Nikon D800E**
Lens: **Nikkor 50 mm 1,4**
Exposure: **ƒ 4,5 • 1/40 sec • ISO 800**

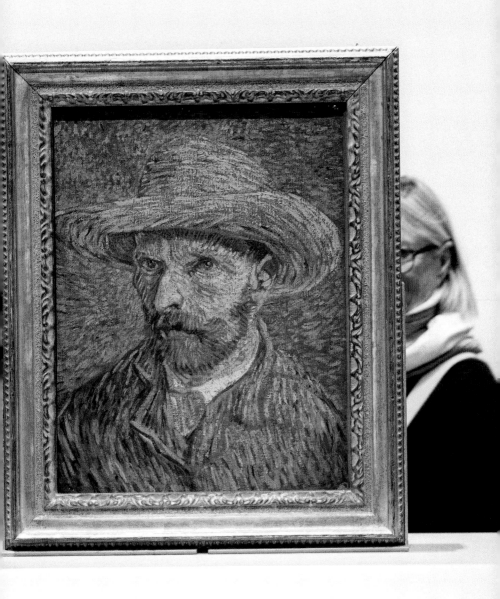

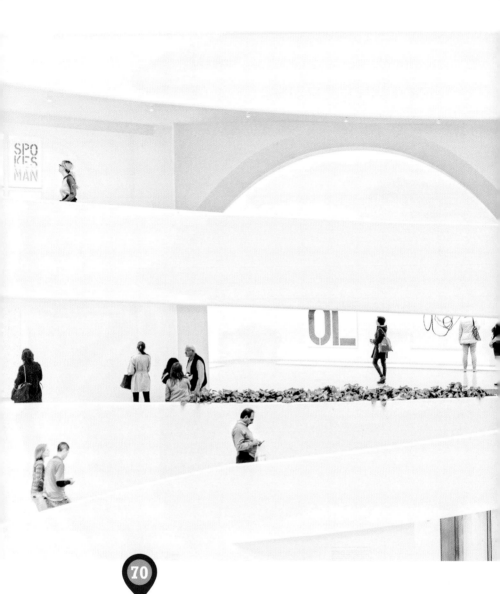

© Pietro Canali
Location: **Guggenheim Museum**
Camera: **Canon 5D Mark III**
Lens: EF24-70 mm f/2,8L USM @ 50 mm
Exposure: *f* 5.6 • 1/60 sec • ISO 1600

GUGGENHEIM MUSEUM

The Guggenheim Museum is an amazing structure. As soon as it was built, it was dubbed the "toilet bowl," but today it is an icon of New York and of museum architecture worldwide. Inside it is just as famous. ... The only pity is no photography is allowed on the upper floors, but there are fewer restrictions on the ground floor. The interior is pure white, and here the photographer wanted to highlight the whiteness of the structure by developing the RAW file in a high key, making the interior glow and chopping off the people as if they were entities or the puppets in a model. Technically it is simply a slight overexposure, with the highlights always carefully controlled.

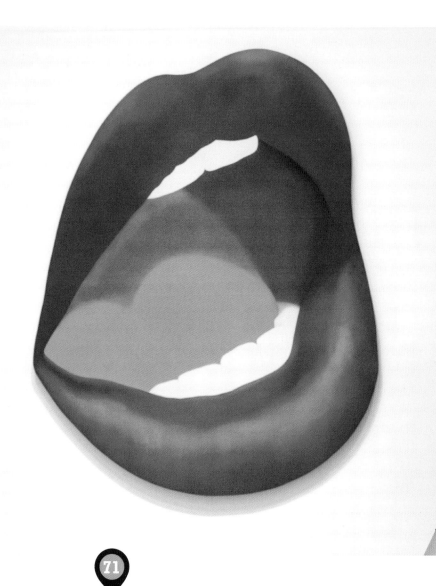

© Corrado Piccoli
Location: The Museum of Modern Art
Camera: Nikon D600
Lens: Nikkor AF-S 24-120 ƒ 4 G @ 44 mm
Exposure: ƒ 4 • 1/40 sec • ISO 3200

MOUTH NO. 7

With more than half the photograph taken up by a highly colored, sensuous mouth floating against a light ground, this is already a highly appealing image. Add that the artist is the genius Tom Wesselmann, who extrapolated parts of female bodies and raised them to objects with a powerful Pop Art flavor. Only one thing's lacking to make this picture unique, and here it comes in the form of a young woman who snaps the mouth with her smartphone, creating an image ready to become her next screensaver or profile picture on Facebook.

NATIONAL 9/11 MEMORIAL & MUSEUM

The National 9/11 Memorial is a must, though you sometimes have to stand in line for a long time.
It is a brand new museum and still photographically unexplored.
As often happens, tripods are strictly banned, because they interfere with the stream of visitors. So a steady hand and high sensitivity are a great help.
To create a powerful image here, the photographer related the huge steel structures–the skeletons of the buildings scorched that day–to the tiny people dwarfed by them.
These are small devices that recount and illustrate the memory of September 11 in gentle, non-invasive and ever-new ways.

72

© Anna Serrano
Location: **National 9/11 Memorial & Museum, Manhattan**
Camera: **Canon 5D Mark II**
Lens: **EF24-105 mm f/4L IS USM @ 24,0 mm**
Exposure: **f 5,6 • 1/60 sec • ISO 2000**

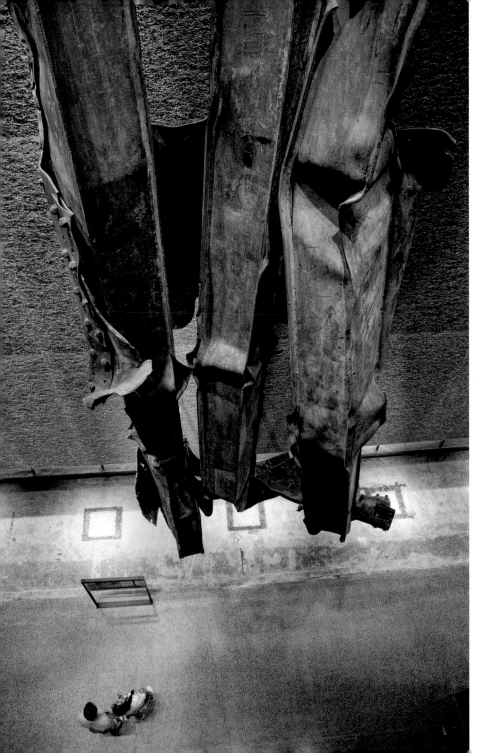

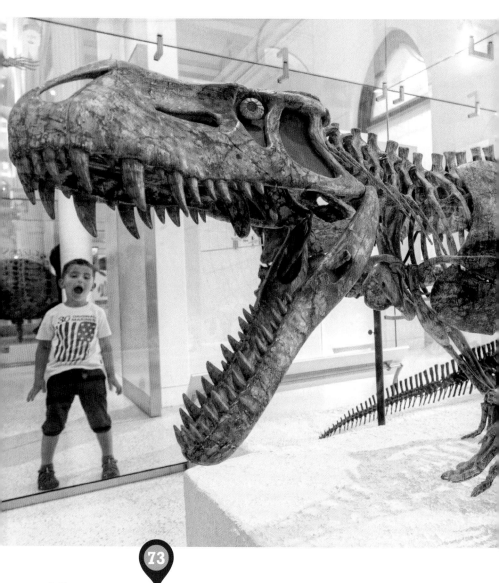

© Giovanni Simeone
Location: **American Museum of Natural History, Manhattan**
Camera: **Sony LCE-7R**
Lens: **FE 24-70mm F4 ZA OSS @ 25 mm**
Exposure: **ƒ 5,6 • 1/40 sec • ISO 1000**

T-REX

Every kid wants to become a paleontologist. We practically live in a new age of the dinosaurs. So a visit to the American Museum of Natural History is a must. To avoid taking the usual pictures of a "koala" (a person or child with some exotic creature in their arms), look around for a more original situation. This photo captures a child's amazement at the sight of Tyrannosaurus Rex with its mouth gaping and ready to bite. High sensitivity film helps (ISO 1000 is no longer a problem for the new digital machines), because of the lack of light, while the other great problem is the reflection in the glass of the display case containing the T-Rex. But the startled look on the child's face really makes the difference here, set right between the jaws of the ferocious prehistoric monster.

FREEDOM TOWER

As you approach this place you
wonder if you have the courage
and strength to stay there.
The first impulse is to put away
the camera, from reverence and
respect for so much suffering.
Why photograph it? And what?
A look at the skyscrapers
disappearing into the clouds
in the sky could offer a new key
to interpreting the place.
The energy is dispelled into the
sky, turning into something else.
An intense spirituality emanates
from the lightness of contemporary
architecture, which merges with the
clouds. A delicate light is the most
suitable. Photoshop certainly lent a
big hand here to achieve what the
photographer had in mind, but the
way the buildings and sky melt into
each other is a complete success,
giving the image an ethereal
lightness.

© Sandra Raccanello
Location: **National 9/11 Memorial
& Museum, Manhattan**
Camera: **Canon 5D**
Lens: **EF28-135 mm ƒ/3,5-5,6 IS USM @28 mm**
Exposure: **ƒ 14 • 1/125 sec • ISO 400**

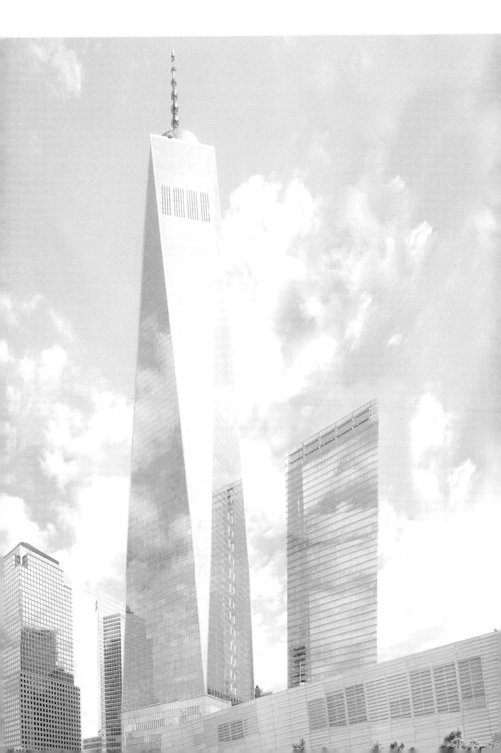

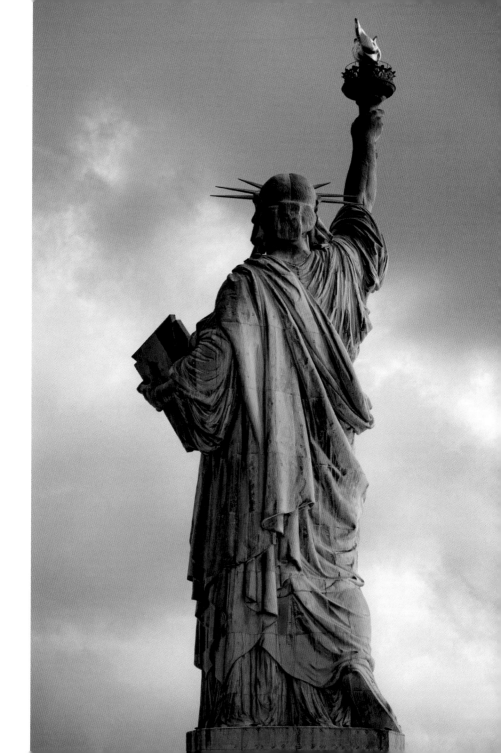

STATUE OF LIBERTY

In life as in photography, it's often a good idea to try looking at things from a new viewpoint. Everyone knows the face of the Statue of Liberty, but few have seen Miss Liberty from behind. Here even the icon seems to want to face the coming storm armed with the torch of freedom alone. The unusual point of view, simple composition, and the sculptural effect of light and shade give this picture a decidedly modern and distinctive appearance. Always keep in mind we are talking about one of the places most widely viewed, photographed, and published in the world. But as usual, the photographer can astonish, invent, and reveal things from a completely different point of view. That's the magic of photography!

75

© Massimo Ripani
Location: **Liberty Island**
Camera: **Canon EOS-1Ds Mark III**
Lens: **EF70-200 mm f/2,8L USM**
Exposure: **f 9 • 1/80 sec • ISO 100**

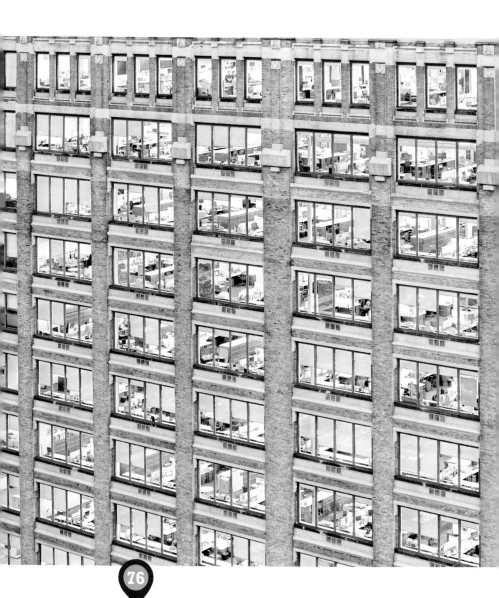

© Pietro Canali
Location: Hell's Kitchen, Manhattan
Camera: Canon EOS 5D Mark III
Lens: EF70-200 mm ƒ/4L IS USM @ 78 mm
Exposure: ƒ 6 • 1/60 sec • ISO 1600

OFFICE BUILDING AT NIGHT

Who says a photograph always has to be beautiful and appealing? We all need reassuring "postcards," but sometimes we have to go further to investigate the poetry and drama of life. So forget for a moment about photogenic qualities, the magic of Central Park, the thrill of the skyscrapers, and the most famous landmarks. Photograph the alienation of modern life between work and home, the skyscrapers like anthills, identical in New York, Tokyo, and Hong Kong. It won't be difficult; you'll find inspiration everywhere. This image is an established classic of contemporary photography–just remember the lesson of Andreas Gursky–and if you think of yourself as a modern photographer, then this style is essential in New York.
A secret: the architecture of the lines has to be straight on the spirit level: not even a single degree of distortion is acceptable.

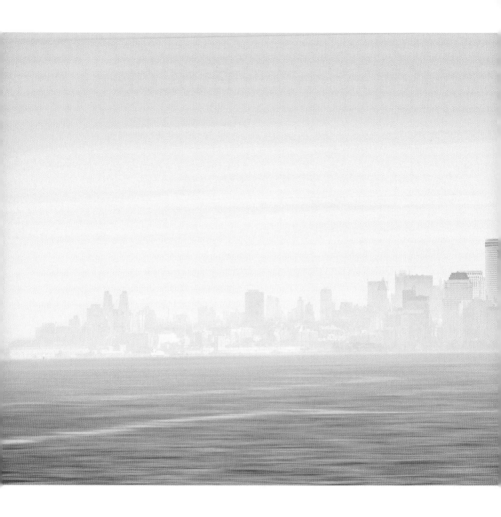

LOWER MANHATTAN

The skyline shot was surely invented in New York. In the eighties and nineties there was the apotheosis of the skyline thanks to perfect photos, panoramic, saturated, and enthralling. Usually the lights of evening or night time were the key feature, a stylistic element that was an emblem of those years, along with photos of sunsets and flowers. Reinterpreting those photos with a new vocabulary forces you to go the other way. The result is an ethereal, monochrome photograph, dreamy without being

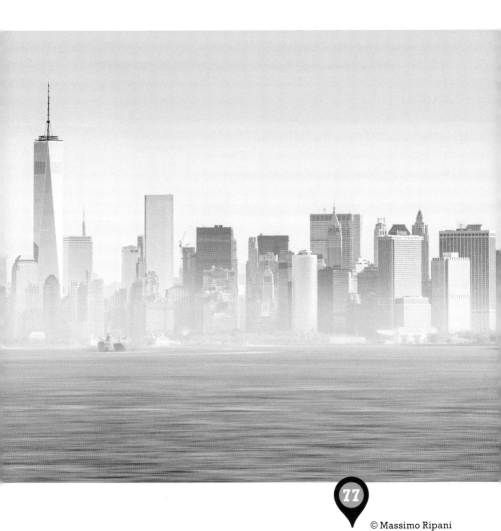

77

© Massimo Ripani
Location: **Liberty Island**
Camera: **Canon EOS-1Ds Mark III**
Lens: **Canon EF 70-200 ƒ2,
8L USM @ 200 mm**
Exposure: **ƒ 6,3 • 1/,500 sec • ISO 100**

blatantly appealing.

Photoshop naturally helps create *modern* images–a very inadequate adjective, as in photography almost nothing is invented anymore, and the work of the future will merely be to refine its vocabulary.

SEEING MODERN TASTE

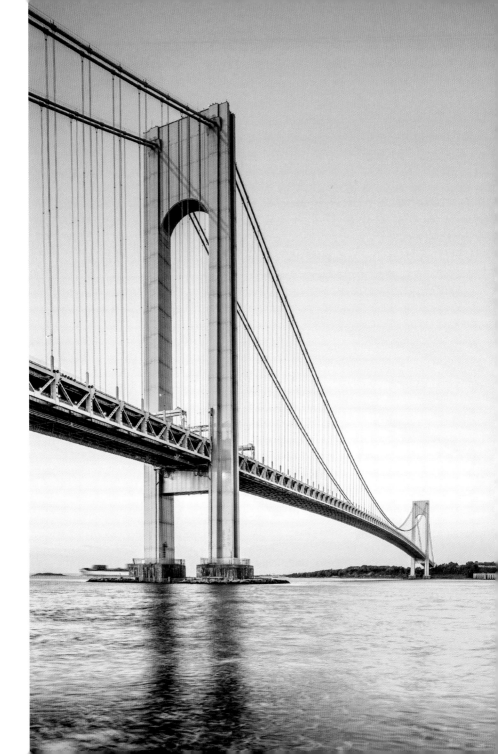

VERRAZANO-NARROWS BRIDGE

Sometimes buzzwords are taken up in photography. For example, the adjective *minimal* can certainly be applied to Hiroshi Sugimoto's work, but in other cases its relevance is doubtful–to landscape photography, for instance. Yet this photo is perfectly minimalist in its composition (it respects the rule of thirds), the use of just two colors, the absolutely pure air, and the light that admits nothing beyond the natural. In cases like this the shot has to be meticulously prepared: the slightest error would have cheapened it into the despicable category of insignificance, sadly the fate of many photos.

© Antonino Bartuccio
Location: **Brooklyn**
Camera: **Canon 5D Mark II**
Lens: **TS-E24 mm, *f*/3,5 L II**
Exposure: ***f* 9 • 2 sec • ISO 100**

SEEING MODERN TASTE

175

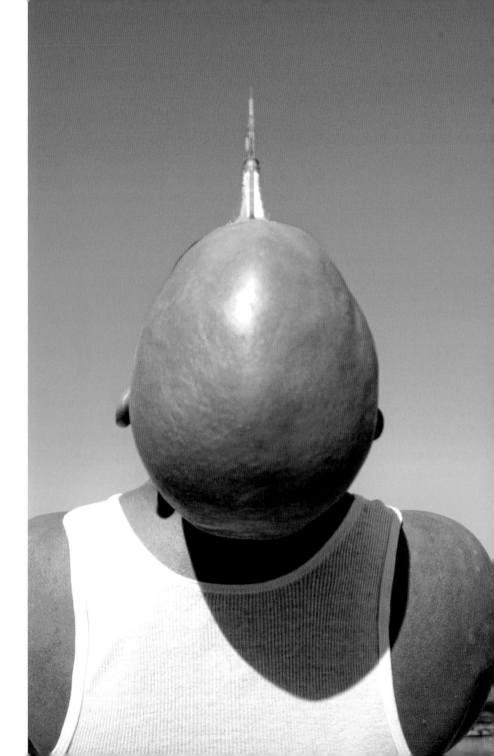

MAN IN FRONT OF THE EMPIRE STATE BUILDING

NY's iconic structures reach their limits—as we walk the streets and look up, as the big city draws your attention to the shapes, the photographer stands behind a young man in awe of what he sees, capturing the juxtaposition of his body, his head, against the quintessential iconic structure, the Empire State Building. But just what is this man doing with the tip of the skyscraper? It is said that the photographer must always provide an answer. In this case the picture intrigues, but still leaves us puzzled. It asks a question, but fails to give an answer. Here is one of those cases where a margin is left to personal interpretation, to the observer's imagination.

79

© J.B. Grant
Location: **28th Street on Broadway**
Camera: **FinePix S2Pro**
Lens: **24 mm**
Exposure: **ƒ 8 • 1/250 sec • ISO 100**

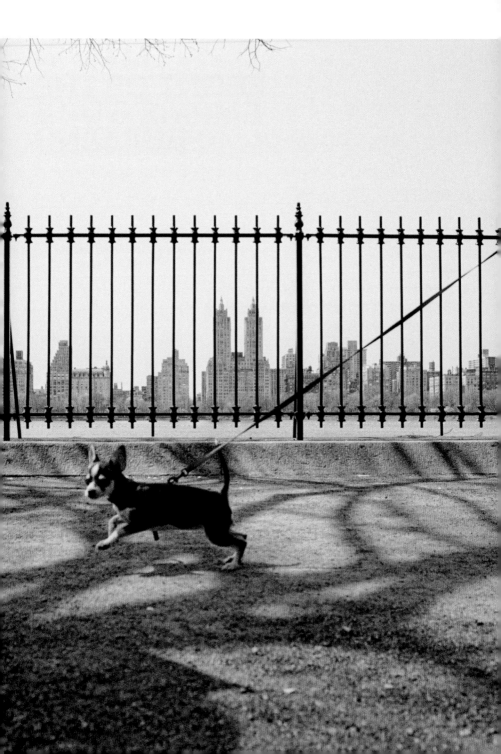

SMALL DOG IN CENTRAL PARK

Remember Elliott Erwitt's famous photo *Felix, Gladys and Rover*? There the alienating effect was generated by the very low viewpoint, practically at eye height with the puppy. This photo does not follow that model, but plays with the surreal effect arising from the approach between the infinitely small (the dog) and the infinitely large (the metropolis). Then add the tyranny of this toy dog dragging its master, and you have the perfect depiction of a certain New York social class and its lifestyle.

80

© Andy McKay
Location: **Central Park**
Camera: **Canon EOS1**
Film: **20-35 mm lens and Fuji 35 mm film**
Exposure: **f 5,6 • 1/125 sec • ISO 100**

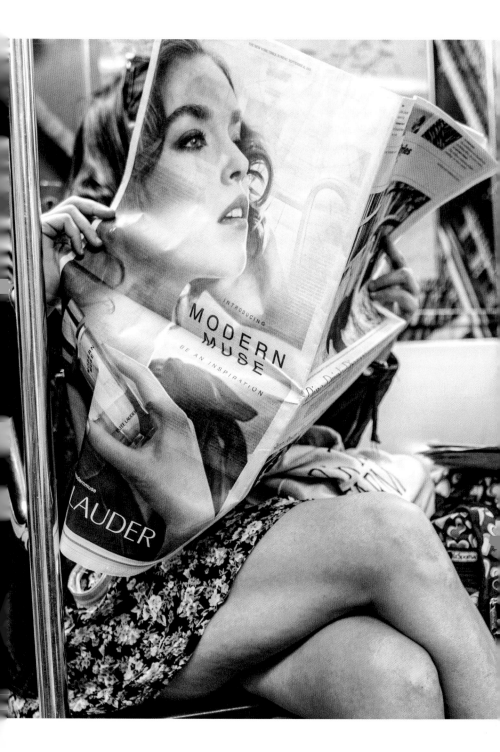

SUBWAY

Quirky camera angles, bold ideas, and a pinch of courage have the power to make an apparently simple shot like this ironic and surreal. A picture snapped on the fly, pounced on with professional flair. The subway is the perfect place to look for inspiration, but you have to be quick and decisive, and above all not annoy passengers with unwanted photos.

In this case the identity of the woman remains concealed, and you create a curious surreal effect due to the overlap of the printed face of the magazine model, which merges with the traveler's body. No special technical device, other than to remember that modern sensors are not at all allergic to high ISOs, while the quality (read degrees Kelvin) of artificial lighting can be altered at home. Two moves, and it's checkmate for King Film!

© Antonino Bartuccio
Location: **Subway, Manhattan**
Camera: **Canon 5D Mark II**
Lens: **EF35 mm, ƒ/1,4L USM**
Exposure: **ƒ 2,2 • 1/50 sec • ISO 1250**

HOMER SIMPSON, TIMES SQUARE

What makes this photo so unsettling? Times Square, the epicenter of all the oddities of the Big Apple, is populated by humanity of all kinds, including people dressed up as comic book and cartoon characters. If we didn't know Homer Simpson is a lazy slob by nature, his sprawling pose would be a perfect example of how cities knock you out. Strangely, the seething crowd in the square seems to have dissolved into a pool of shadow behind him, creating a veiled melancholy accompanied by a muting of the brilliant colors of the skyscrapers. To avoid distorting them, a 24 mm shiftable lens was used to keep the lines absolutely straight!

82

© Antonino Bartuccio
Location: **Times Square**
Camera: **Canon 5D Mark II**
Lens: **TS-E24 mm, f/3,5 L II**
Exposure: **f 8 • 1/250 sec • ISO 100**

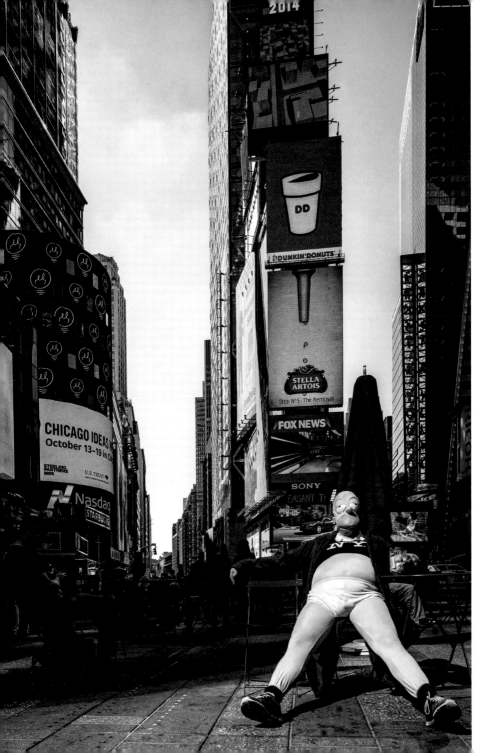

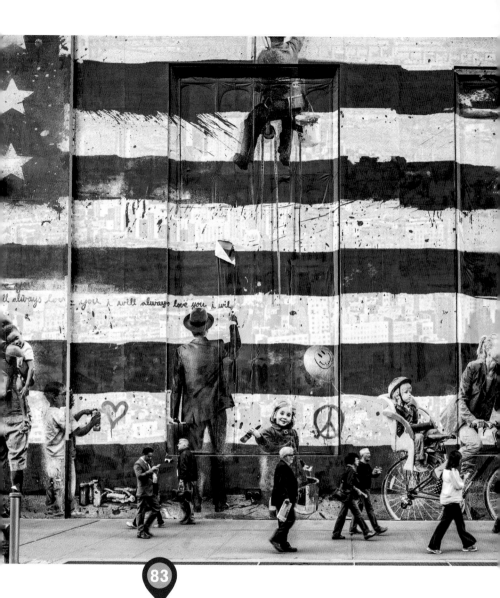

© Antonino Bartuccio
Location: Fulton Street, Manhattan
Camera: Canon 5D Mark II
Lens: TS-E24 mm, ƒ/3,5 L II
Exposure: ƒ 6,3 • 1/60 sec • ISO 640

THE FLAG

A great mural with the Stars and Stripes, populated by various characters typical of the American way of life (a mother with her child on her bike, a window cleaner hanging from a skyscraper, another family scene on the left, two writers). The passersby in flesh and blood three times smaller make a surreal image, dwarfed and made unreal by the figures in the mural. This was a difficult picture to take, since there was no sidewalk on the other side of the road where the photographer could lurk, and the cars were whizzing past. It meant being quick and timing the red traffic light, shooting before the traffic started up again.

* By their nature, urban murals and graffiti are impermanent. The publisher apologises if the City of New York painted this wall.

LEGALITIES* OF STREET PHOTOGRAPHY

When photographing on location outside of a controlled studio environment, it's helpful to know what kind of photography is permitted and what isn't.

Broadly speaking, there are no restrictions on what you can photograph if you're on public land. That doesn't mean that you can take over that piece of public land and cause obstruction since everyone has equal right to be there, but you don't need a permit or permission to photograph the people that share the space. Nevertheless, you need to respect your subjects' personal space without intrusion. The relationship with your subject changes when they become participants in the process of your photography, if for example you direct them, because now they're "models," not candid subjects; and you should consider investing the time and charm to obtain your model's signature on a model release form. Doing so could protect you from spurious claims for harassment or demands for further payment in the future if your image is published or widely distributed.

Not all freely accessible places are public land; so parks, gardens, shopping malls and museums will have their own rules regarding photography, and you may be asked to stop photographing or invited to apply for a permit. Usually, you may photograph private buildings or property from public land, but you should seek permission from the owners of the private property in both cases.

The police may prevent you from photography if they seal off an area of public land. "Police Line" and "Do Not Cross" signage should be obeyed. The police may demand sight of your images, but they cannot make you delete them on the spot. If approached or questioned by police, it's best to be open and cooperative. When out photographing, be polite to everyone you come into contact with: police, passers-by, security. Whilst you don't need to ask permission to take pictures in a public space, doing so could further your objective of getting great pictures. If people clearly don't want to be photographed, just stop. Continuing is ill-advised and could lead to unpleasant consequences.

*these are intended as common sense guidelines and should not be construed as legal advice.

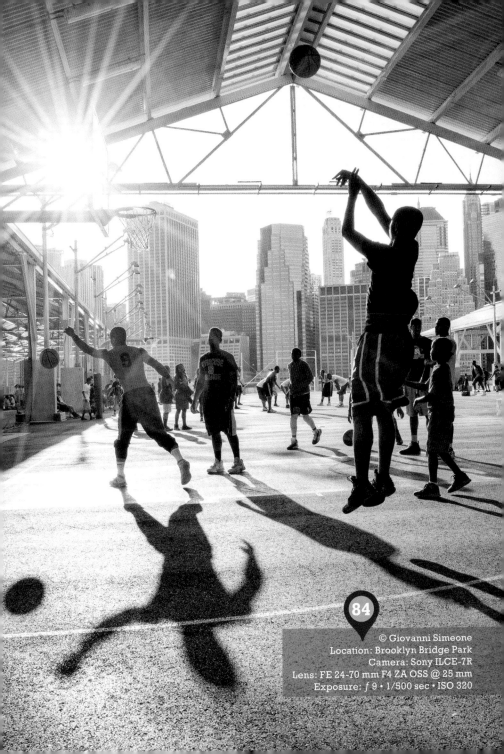

84

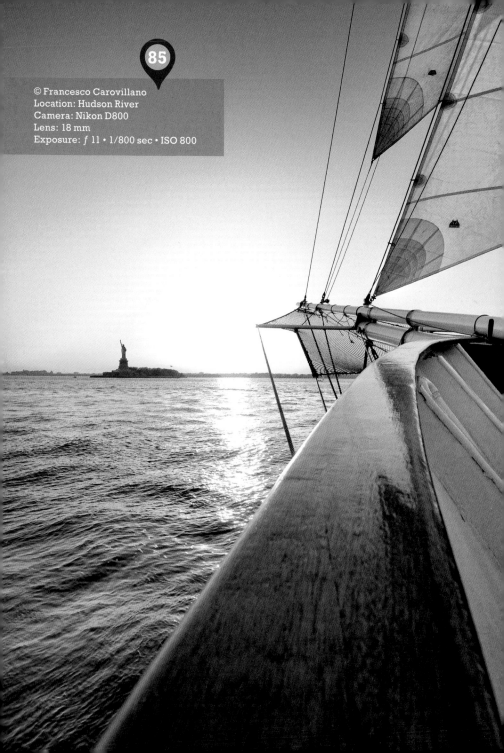

85

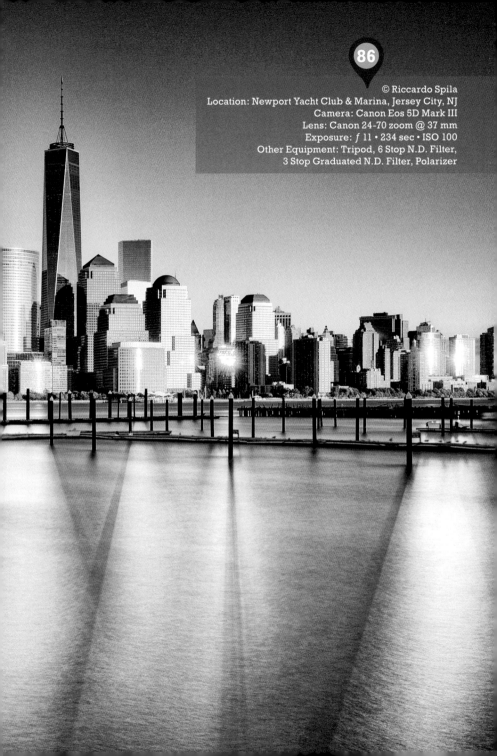

87

2016 © SIME BOOKS

Text
William Dello Russo
Carlo Irek
Giovanni Simeone
Translation
Richard Sadleir
Photoediting
Giovanni Simeone
Design
Jenny Biffis
Prepress
Fabio Mascanzoni

All the photos are available from
www.simephoto.com

Flaps:
New York from Long Island Sound
© Corrado Piccoli
Location: Tod's Point, Greenwich, CT
Camera: Nikon D600
Lens: Nikkor AF-S 24-120
f/4 G EDVRII @120 mm
Exposure: f 5,6 • 1/200 sec • ISO 100

I Edition 2016
ISBN 978-88-99180-55-3

Sime srl
www.sime-books.com
T. +39 0438 402581

Distributed in United States by
SUNSET & VENICE, LLC
www.sunsetandvenice.com
T. 323 223 2666S